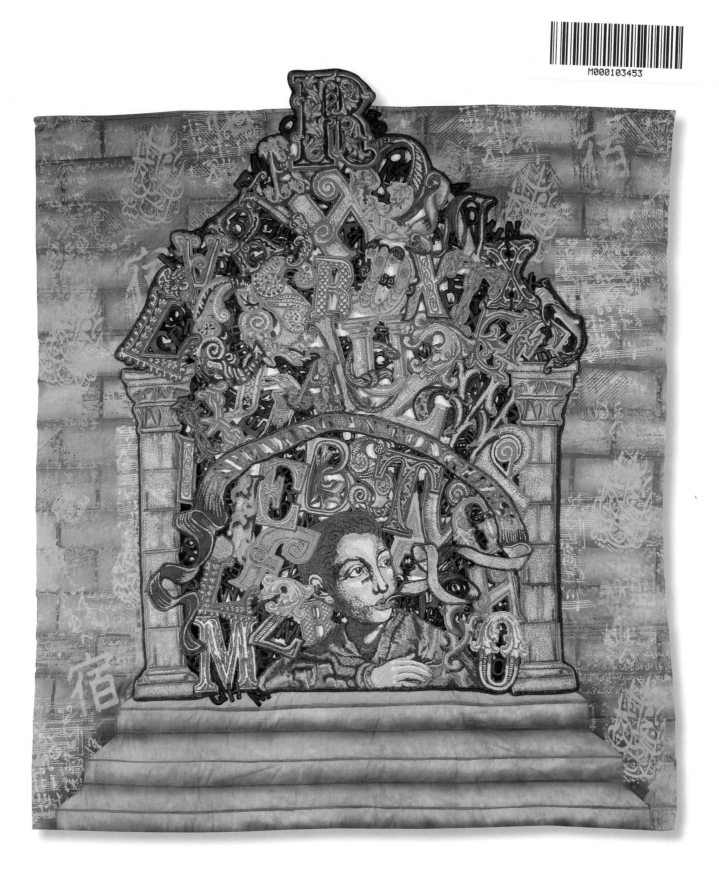

M. JOAN LINTAULT: CONNECTING QUILTS, ART & TEXTILES

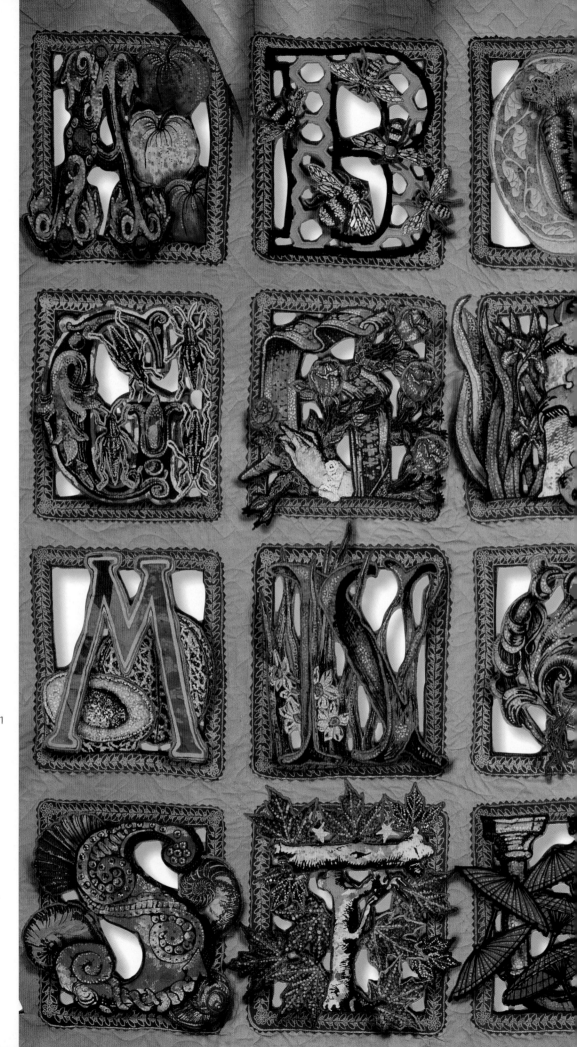

Editor in Chief: Linda Chang Teufel

Graphic Designer: Kimberly Koloski

Photographer: M. Joan Lintault
(unless otherwise noted)

Copy editor: Pat Radloff

Publisher's Cataloging in Publication Data

Lintault, M. Joan

Connecting Quilts, Art & Textiles

 1. Quilting

 2. Textiles

 3. Machine quilting

 4. Art

I. Title

Library of Congress
Catalog Card Number: 2007934010

ISBN# 978-0-9641201-4-3

Printed in Thailand

9 8 7 6 5 4 3 2 1

Dragon Threads Ltd.
490 Tucker Drive
Worthington, OH 43085

www.dragonthreads.com

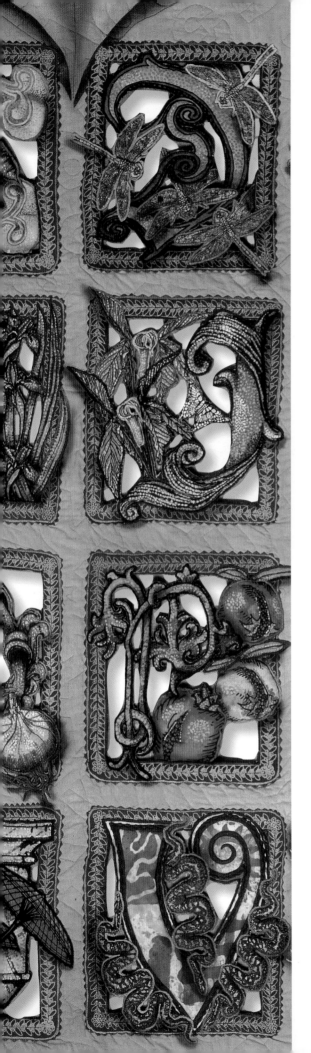

DEDICATION

This book is dedicated to my father who took me to museums while I was growing up. He gave me things even before I knew that I needed them, and always made sure I had enough paper.

To my children, Ian and Marcus, who were my dye and printing assistants; they are the reason to keep on going.

To Robert Shaw, who understands. Thank you for everything you have done.

To my Aunt Florence, who told us the best stories every summer day. I will never be able to approach the magic she gave us.

To Dorothy, who was never alarmed when meeting all sorts of different beings. She said "We aren't in Kansas anymore."

To Alice, from whom I got permission to look at things differently when I am on an adventure.

ACKNOWLEDGMENTS

My sincere thanks and gratitude to Linda Teufel, my publisher, for her patience. She called me up one day and gave me an offer that I couldn't refuse.

The handsome results of this book can be credited to Kim Koloski. Thank you.

I would like to acknowledge Bob Barrett, New Paltz, NY, and Dan Overturf, Carbondale, IL, who took such excellent photographs of my work.

I am eternally grateful to my friend, Debra Tays, who organized my exhibitions with such quiet generosity.

Special thanks go to my sister, Jaime Uhlenbrock, who edited my work and takes care of and helps me during terrible times.

Thank you to Anthony Thwaite for permission to print his poem *Archeology*.

Contents

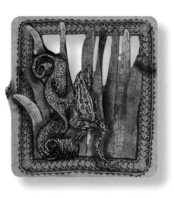

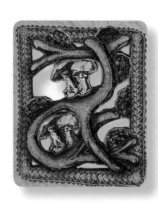

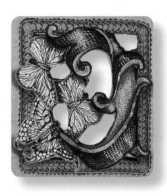

Begin at the Beginning

Gallery

Six Impossible Things
Before Breakfast

9

15

55

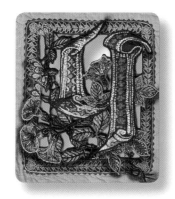

MAGIC OF LIGHT,
MYSTERY OF SHADOWS

THE TRIP DOWN
THE RABBIT HOLE

VISUAL CRITIQUE

THE WIZARD BEHIND
THE CURTAIN

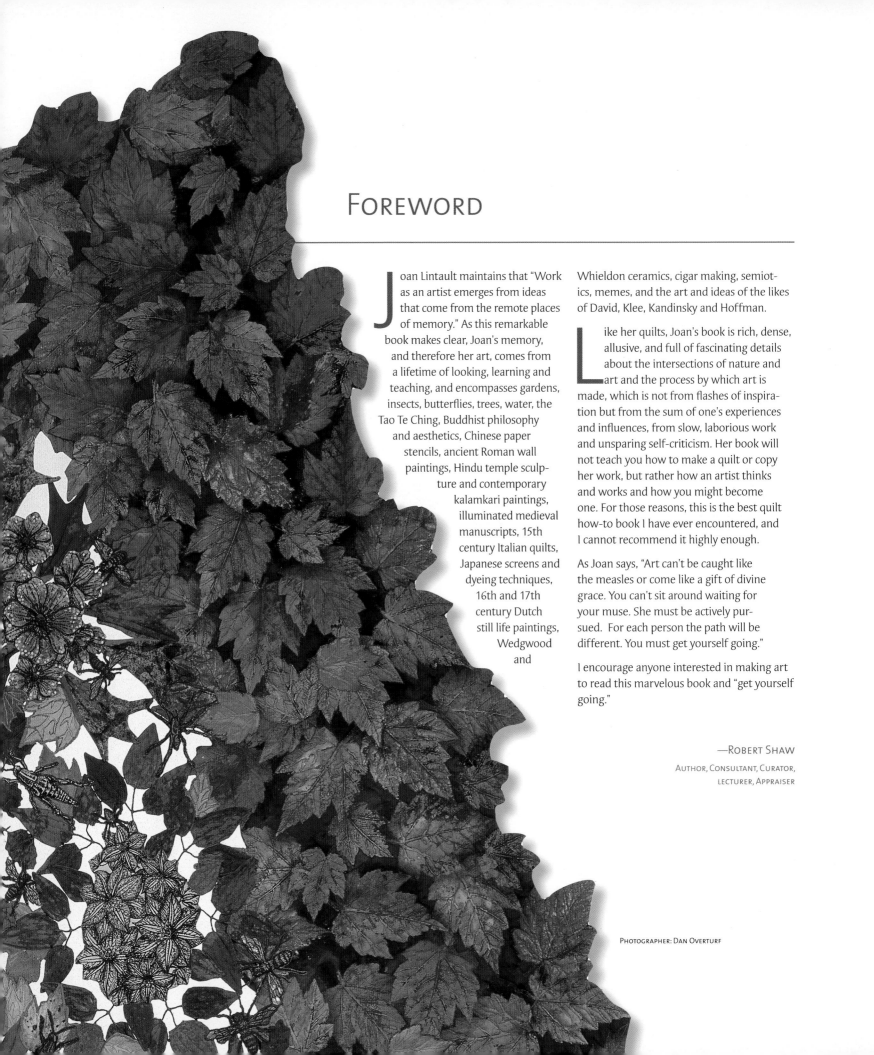

FOREWORD

Joan Lintault maintains that "Work as an artist emerges from ideas that come from the remote places of memory." As this remarkable book makes clear, Joan's memory, and therefore her art, comes from a lifetime of looking, learning and teaching, and encompasses gardens, insects, butterflies, trees, water, the Tao Te Ching, Buddhist philosophy and aesthetics, Chinese paper stencils, ancient Roman wall paintings, Hindu temple sculpture and contemporary kalamkari paintings, illuminated medieval manuscripts, 15th century Italian quilts, Japanese screens and dyeing techniques, 16th and 17th century Dutch still life paintings, Wedgwood and Whieldon ceramics, cigar making, semiotics, memes, and the art and ideas of the likes of David, Klee, Kandinsky and Hoffman.

Like her quilts, Joan's book is rich, dense, allusive, and full of fascinating details about the intersections of nature and art and the process by which art is made, which is not from flashes of inspiration but from the sum of one's experiences and influences, from slow, laborious work and unsparing self-criticism. Her book will not teach you how to make a quilt or copy her work, but rather how an artist thinks and works and how you might become one. For those reasons, this is the best quilt how-to book I have ever encountered, and I cannot recommend it highly enough.

As Joan says, "Art can't be caught like the measles or come like a gift of divine grace. You can't sit around waiting for your muse. She must be actively pursued. For each person the path will be different. You must get yourself going."

I encourage anyone interested in making art to read this marvelous book and "get yourself going."

—ROBERT SHAW
AUTHOR, CONSULTANT, CURATOR, LECTURER, APPRAISER

INTRODUCTION

I n 1988, after having struggled with the direction of her art work for about ten years, M. Joan Lintault realized it was the quilts she had made (and liked) in the past that most "felt like her". She credits this moment with having had an "epiphany" and focused her work more closely in this direction.

Right around that same period, Joan specifically remembers walking down a New York City street in the dead of winter when a store captured her attention. Outside and in front of the building was a very beautiful, cascading display of flowers, flowers of every description and color from different corners of the earth.

After returning home, she went into a supermarket and she was again captivated by the most incredible display of brightly lit fruit and vegetables. Her reaction was the same ---one of incredible abundance.

With these images in mind, Lintault looked more closely at artists and images that had always interested and inspired her. Of these, for example, there was the work of a 16th century Italian painter named Giuseppe Arcimboldo who painted fruits, vegetables, animals and allegorical portraits, and the 17th-century Amsterdam artist Rachel Ruysch, who painted still-life images of flowers, insects and reptiles. Other favorites included the work of the 18th-century ceramists Jacob Petit, Thomas Whieldon, and Josiah Wedgewood, who created bowls, dishes, and platters in the shape of fruit, vegetables and animals.

Through their work, they were able to turn a tabletop setting into a garden landscape.

Joan drew on past events and experiences that she had gained mostly from traveling and studying in several countries, with lessons and memories that were finally "locking in".

Of these, her most intrinsically important experience came on a trip to Japan in 1984. While on a nine-month Fulbright Research Grant as Visiting Scholar in Kyoto to study kusakizome (grass and tree dyes), Joan developed a deep interest in Japanese aesthetics. During the course of many conversations she often told me that the best art history course she ever took was on Japanese art. She felt that there is so much emotion and spiritual richness connected with the Japanese sense of aesthetics and whose particular type of beauty evident in Japanese art is visible mainly by the use of materials. It is through this aesthetic, the beauty of simplicity and harmony in life, that things are seen as intuitive, imperfect, impermanent and incomplete. Joan refers to this idea as "the pathos of things." When Joan left Japan it had profoundly changed the way she would approach her own work.

A nother trip that had a profound impact on Joan's work was a trip to Italy to visit her sister in 1986, who was on a sabbatical leave from her University conducting art historical research. They went to museums, gardens, villas, churches, palaces and ruins, where manuscripts, frescos and wall paintings were located. In particular she was af-

fected by ancient Roman garden rooms and Renaissance techniques of wall paintings. They exhibited the beauty of the images and the complexity of the symbolism.

During the last several years, Joan has focused her research on the history of the first gardens of the world. In its earliest form, the garden was a place of bliss, offering supreme delight, portraying nature as divine presence, a place where man and nature live, in perfect harmony, a pleasure garden. The Greek word for this type of garden was paradeisos or paradise. It is through her quilts in her series Evidence of Paradise that Joan reinterprets visual images and metaphors of paradise.

T he wellspring for this work comes from events, past journeys, research and a drive for personal growth. Lintault presents visual and symbolic images in an objective and unbiased way, offering the opportunity for unfettered thinking and allowing the observer to be challenged mentally.

She starts her work from raw fabric, which she then dyes, screen-prints, paints and draws on. She assembles her imagery in an openwork style using appliqué, embroidery and machine-made lace to connect it all. There is no background, only foreground, emphasizing all the elements of the quilt composition.

Although Joan places herself solidly in the textile tradition, ultimately she would like to be recognized as part of a continuum of artists who celebrate nature and paradise.

—DEBRA TAYES,
ASSOCIATE CURATOR OF FINE ART,
ILLINOIS STATE MUSEUM

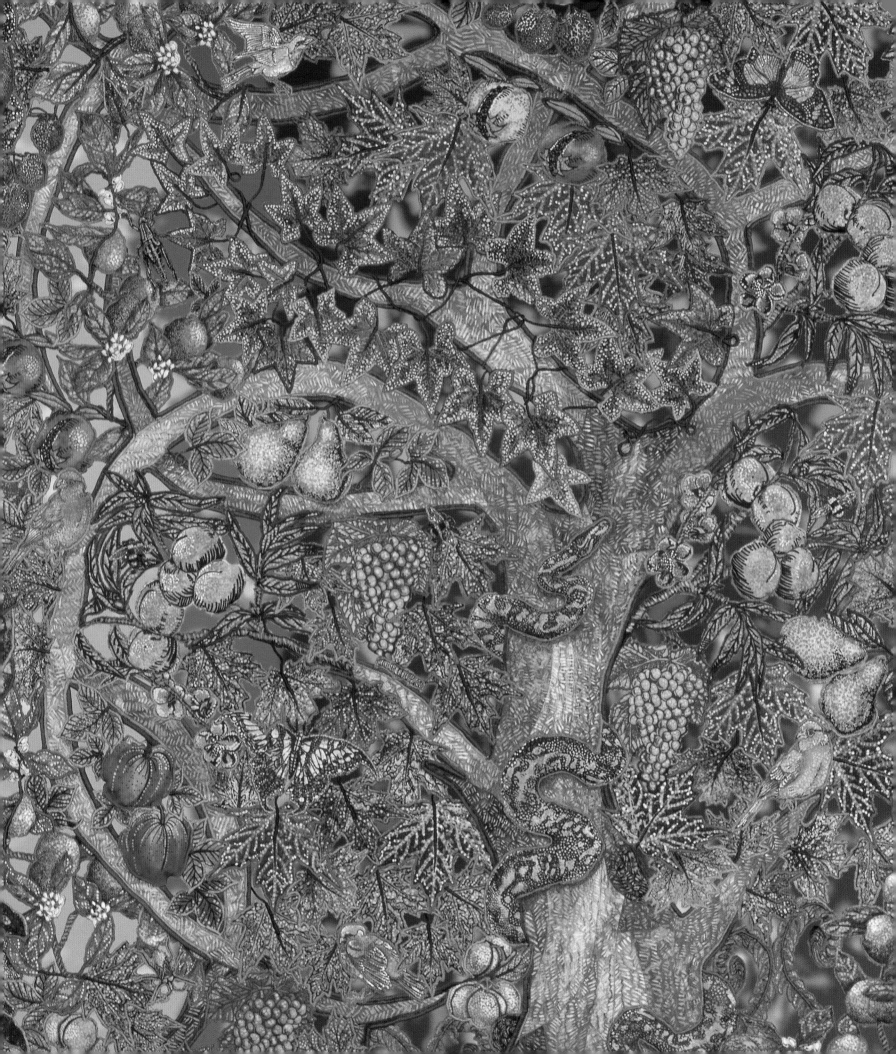

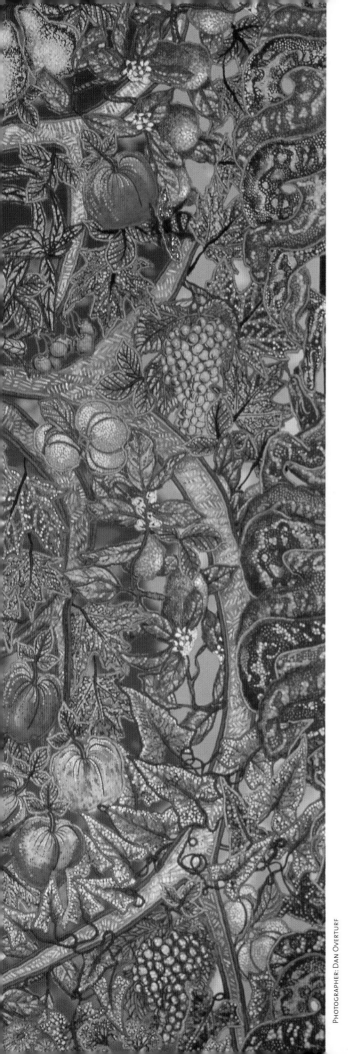

BEGIN AT THE BEGINNING

"Begin at the
beginning,"
the King said very gravely,
"and go on till you
come to the end:
then stop."

—LEWIS CARROLL,
Alice in Wonderland, 1865

My work begins with a blank page, an image and a sentence, then with the desire to visually tell my own tale.

Each person's identity is an accumulation of the myths, rituals and legends of a cultural background merging with a life's story. We can remember where we have been, who we are right now and, because of that, what we hope to become in the future. These recollections are what make us human. All these experiences can make a tale.

Being able to tell my own story is a way of claiming my personal identity. Everything depends on the telling of the tale and the way it is told. Being able to tell a personal history can transform one from a person who is creatively trapped to one who is free.

The telling is not the end; there must be someone to listen, see, and understand.

My tales look to the past, to beginnings, and perhaps to a future path that has no end but only other beginnings.

How do we tell a tale? What will the format be; that is the first issue. For me the medium is cloth. How can I make that cloth special and make it a vital connection between my art, my tale and myself?

My work is first and foremost about the visual and formal elements of art: line, shape, color, form, negative space and positive shape, texture both real and implied and how these elements function on the picture plane I've created. I think that these elements are what make artwork powerful. The fact that I choose to use a particular arrangement of images is secondary. The images

Anonymous Roman painter.
Garden Room at the Villa of Livia at Prima
Porta, 30 B, Museum Palazzo Massimo, Rome

are just the subject matter but are useless unless my elements are visually arranged.

I like to talk about my work in formalist terms. I prefer not to write about my work exclusively in terms of feelings or inspirational stories. I think that people (especially quilt makers) want to be spiritually uplifted by a story, to be engaged first by the subject rather than the artistic in the work. The formalist aspects seem to be second or not at all. I am always asked to write about the inspiration behind my work. Most of the time the inspiration is not immediately evident before I start working. The inspiration evolves during the process of working and sometimes not until I am finished with a quilt.

I do like to write about what has influenced my work historically. But what drove me to choose those particular images I use is not one uplifting moment, but a lifetime of looking, reading, and being passionate about the power of the visual image.

I begin my work with white fabric because I see its possibilities. Fabric can be used in many different ways. It is an obedient, forgiving material. I want every process and technique that I use to contribute to the content of my work so I dye, print and paint my own images. The nature of fabric is that it accepts color and so it is more responsive to me. But I also like to yield to what happens with the process while I work.

Anonymous Roman painter. Garden Room at the Villa of Livia at Prima Porta, 30 B, Museum Palazzo Massimo, Rome

Fabric is sensual and can be manipulated. It can be made to have weight, mass and texture. Atmospheric effects can be created when fabric is translucent, transparent and reflective causing its appearance in light to be changed. For me, the result is a material with the potential for an infinite expression and expansion of form.

I place myself solidly in a textile tradition and because of that I feel free to use any textile technique that could contribute to my work. I look back in history to see where I came from, but the new comes from working as it was with my predecessors, the embroiderers, the quilters, and the lace makers who worked with fabric and thread. Time is not a factor when I work. I do not choose to reject a technique simply because it is laborious. I base my work on geological rather than TV time. I am obsessed with every colored spot of dye and how it looks next to another colored spot. The use of my fabrics has led me to create a body of work that begins with the dyeing and printing of the fabric to its construction on the sewing machine. Using the technique of free-motion embroidery on the sewing machine has allowed me to introduce texture and lace in my work, and to build the quilts in a unique way. My quilts are not pieced, appliquéd, constructed, sewn or quilted in the traditional way. I sew the individual elements together by quilting and using sewing machine lace and embroidery. Some of the lacework that joins the pieces together results in negative spaces. The negative spaces are the silences between the highly active, painted forms. Because of the manner in which I sew the elements together, it appears that the quilt is hanging in space. The irregular outlines of my work create a dynamic edge that frames the work and allows the outside environment to define the edge of the quilt. This enables me to eliminate the traditional ground or background that is usually used to hold the image together.

My objective is to produce a series of quilts that are motivated by metaphors and the evocative use of nature and objects. I want the technique and fabric to enhance my subject. With the basic theme of paradise and portraits, and the use of my imagery, I place myself among those artists who have established an unbroken history of works of art dealing with these themes of paradise and portraits. The subjects that I wish to address are largely traditional and symbolic, such as trees, garden, flowers, insects, animals, fruit, vegetables and various objects. These subjects offer me associations with many levels of meaning.

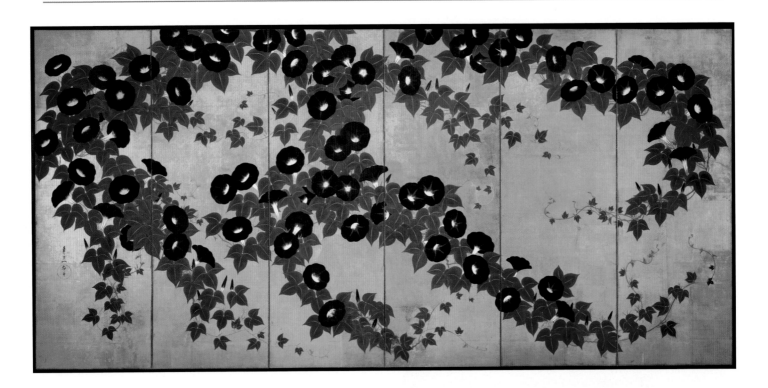

Japanese screens and 1st century Roman garden rooms particularly inspire me. They are historical works of art that use nature symbolism.

The wall paintings in Imperial Roman garden rooms of the late 1st-century B.C. and early 1st-century A.D. are rich in symbolism. In these rooms, people could refresh their minds while contemplating nature. The same interest in contemplation was used as the basis for Japanese screens. The images on the screens are meant to provoke an appreciation for the beauty of nature and the Japanese idea of mono-no-aware, the "pathos of things" and the acceptance of melancholia as an essential ingredient of life.

Having seen what inspires me you can see how these things are reflected in my work. Recently I have concentrated on the themes of paradise and portraits, presenting them in series. For my Paradise Series, I have chosen trees, leaves, flowers, fruit, vegetables and insects for similar reasons. I want to construct the character of nature and paradise from its smaller, more intricate parts. I also want to bring a perpetual summer indoors, from the cool of the forest to the heat of the meadow and to the whine of insects in the grass.

My love of nature began when I was a child and I spent the summer with my sister and cousins at my uncle's farm. I loved the barns, animals, insects, flowers, mountains, creek

Suzuki Kiitsu (Japanese 1796-1858). Morning Glories, *Japanese, Edo period, six-panel folding screen; ink, color, and gold on gilded paper, 70 3/16 x 149 1/2 in. The Metropolitan Museum of Art, Seymour Fund, 1954 (54.69.2). Image © The Metropolitan Museum of Art*

and fields. At night we would lie on the grass and look with wonder at the celestial vault.

Aside from my interest in nature, I also have explored the idea of the portrait. However, my current portraits are not realistic, point-to-point representations of a subject, but rather substitute images that stand in for the original subject. They are composed of symbolic shorthand, where images and details that are entirely different from the original subject are used in order to gain symbolic expression or tell a story.

There are two figures in the portrait painting *Antoine-Laurent Lavoisier and his Wife* by Jacques-Louis David. Included in the painting are objects that give an indication of who the figures are. Because of the clothing they are obviously persons of means and importance. In addition, the position of the figures in the painting shows their affection for each other. Included in this painting are the chemical apparatus essential for the work of Lavoisier. This apparatus in the painting is necessary because it helps to describe who the person was and what he did.

Lavoisier wrote *Traite Elementaire de Chimie*. The illustrator for this book is his wife, the female figure in the painting whose drawing portfolio rests on the chair. This portfolio of drawings describes Lavoisier's wife, Marie-Anne-Pierrette Paulze, as a creative person.

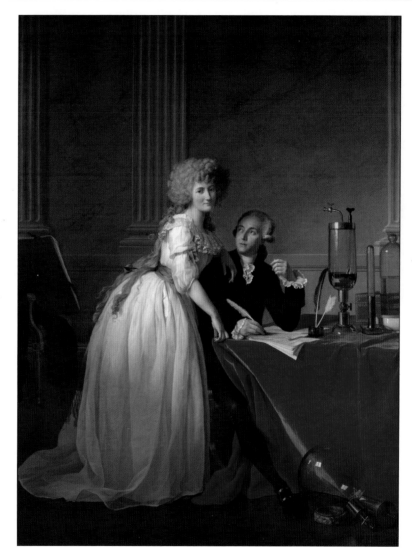

Jacques-Louis David (French, 1748-1825). Antoine-Laurent Lavoisier and his Wife (Marie-Anne-Pierrette Paulze, 1758-1836), 1788, Oil on canvas, 102 1/4 x 76 5/8 in. The Metropolitan Museum of Art, Purchase, Mr. and Mrs. Charles Wrightsman Gift, in honor of Everett Fahy, 1977 (1977.10). Image © The Metropolitan Museum of Art

Lavoisier is known for his pioneering studies of oxygen, gunpowder and the chemical compounds of water.

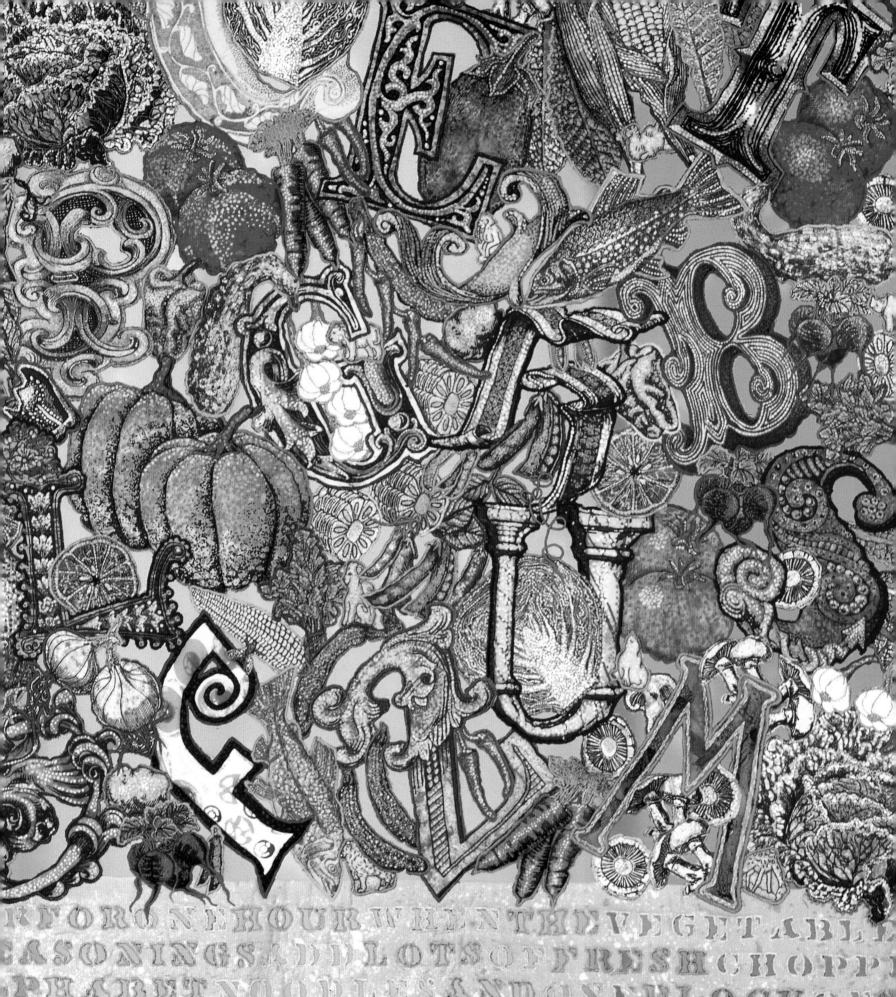

FOR ONE HOUR WHEN THE VEGETABL
SEASONINGS ADD LOTS OF FRESH CHOPP
PHABET NOODLES AND ONE BLOCK OF
OL FOR SEVEN MORE MINUTES OR UNTIL T

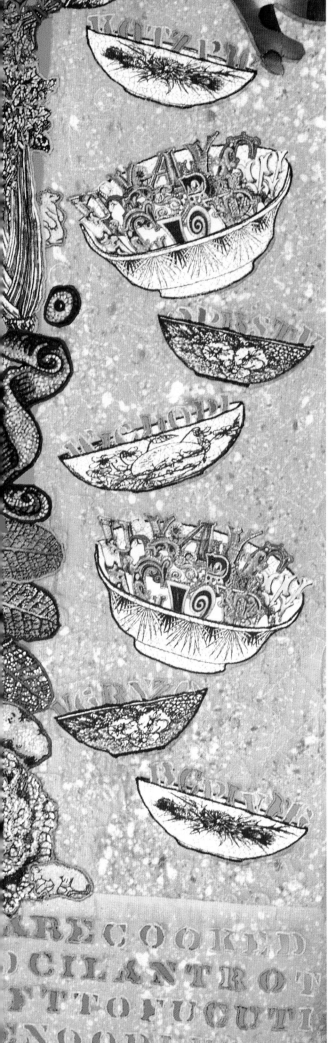

GALLERY

PHOTOGRAPHER: DAN OVERTURF

La Chola en La Colcha

1966. Pieced, quilted, cotton, velvet, corduroy, 85.5 X 109 in., 217 X 278 cm. Private collection

This quilt was my first. As I was working on it I began to question everything connected with making it—hand sewing vs. machine, hand dyed vs. commercially dyed fabric. With this quilt began a quest to look for dyes I could use at home that were colorfast to washing and light. I began to look for ways to pattern fabric other than what was available in the stores because I wanted the images on my fabric to reflect the content and subject of my quilt.

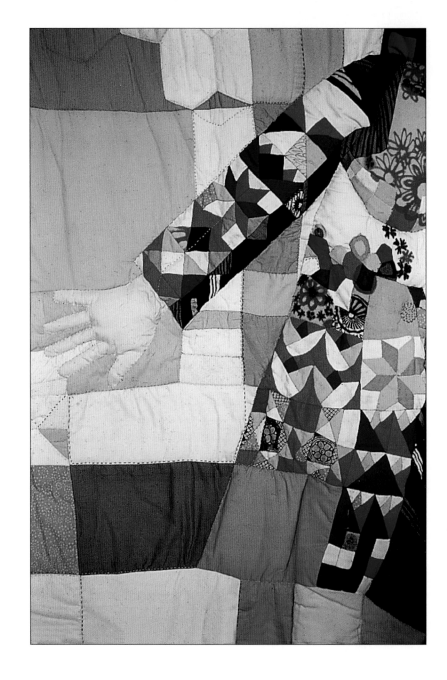

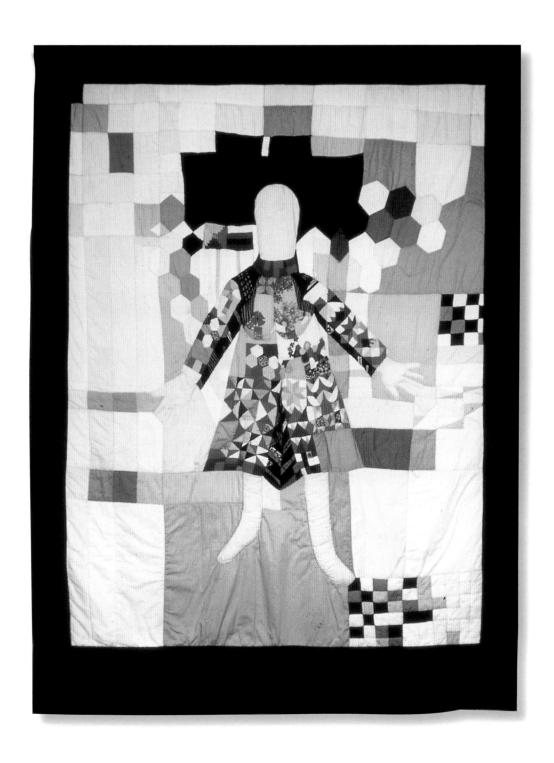

HEAVENLY BODIES

*1979. Xerox heat transfer, poly/cotton,
pieced, quilted 81 X 84 in., 206 x 213 cm.
Rocky Mountain Quilt Museum,
Golden, CO*
PHOTOGRAPHER: FRANCES LLOYD

This is the quilt that changed the direction of
my work. It is pregnant with the elements of
all my work to come—the concern with the
use of image, the negative space which con-
trasts with the volume of the cloth and the
reflections on the wall. Xerox photo transfers
were used for the images on this quilt. At this
time, I was using many photographic tech-
niques on fabric, including photosensitive
dye, blue printing, brown printing, solvent
printing, Polaroid transfers and decals.

This is a portrait quilt I made about
the birth of my friend's baby.

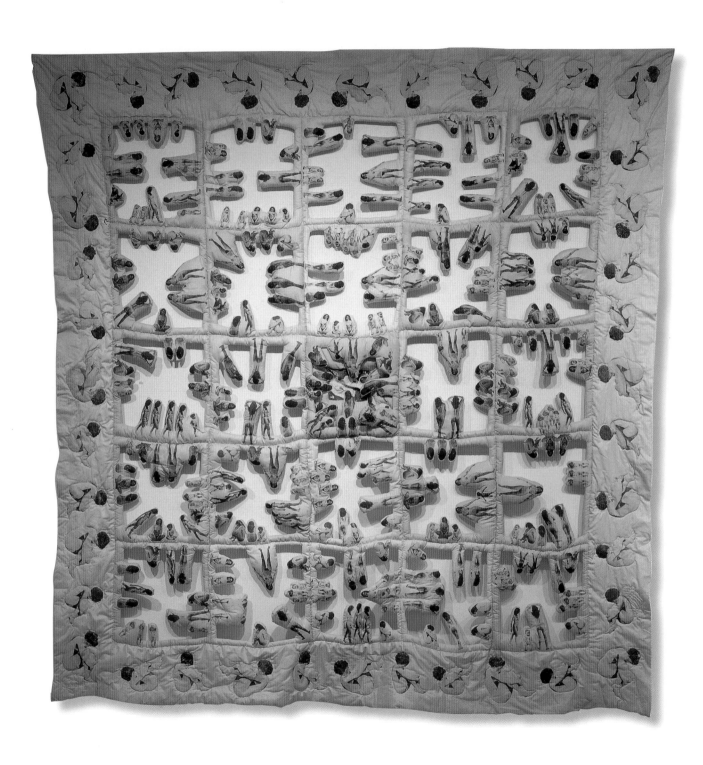

MOUNTAIN TORRENT

*1991. Hand dyed, screen-printed, painted
cotton, appliqué, quilted, sewing machine
lace. 87 X 99 in., 221 X 252 cm.
Private collection*

PHOTOGRAPHER: DAN OVERTURF

I have always been fascinated with lace, not
only by the delicacy of the structure, but also
by the transparency and the shadows cast
on the wall when it is hung up at an exhibi-
tion. During the time I made this quilt, I was
experimenting making lace on the sewing
machine. I was not interested in replicat-
ing delicate handmade lace, but rather I
wanted to use lace to connect the elements
of my quilt and to create open spaces.

This quilt, as well as all my other
quilts, is a construction and engineer-
ing problem. It is extremely difficult to
make the lace hang straight and to fas-
ten the various elements together.

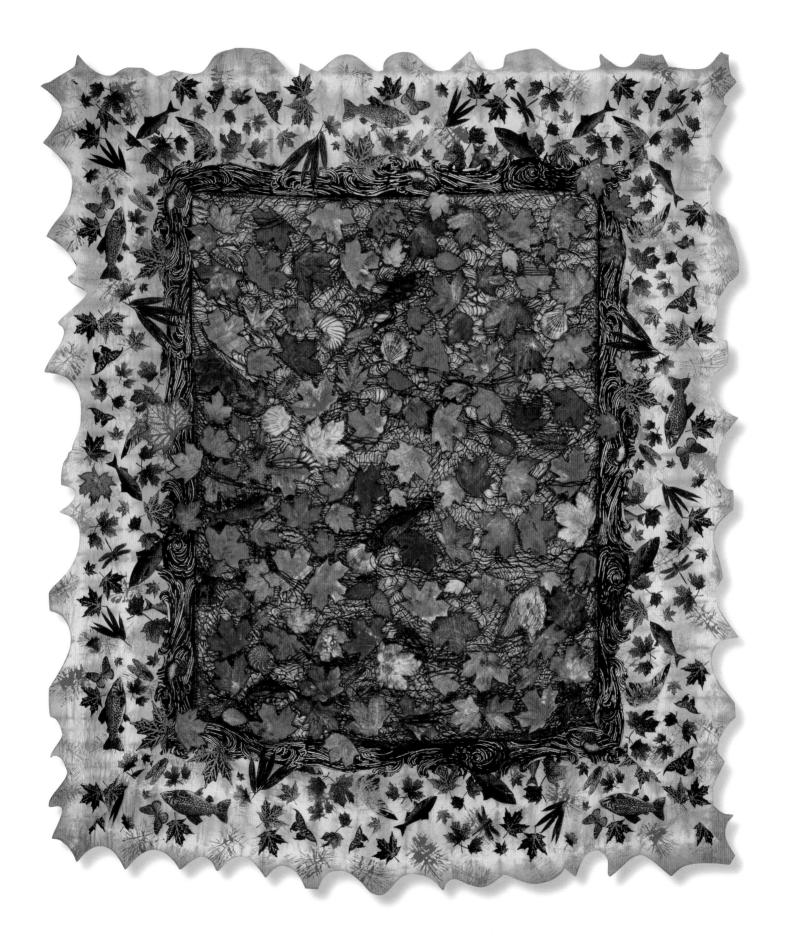

THE FLOWER THIEVES

1992. Dyed, screen-printed, painted cotton,
appliqué, quilted, sewing machine lace.
82 X 99 in., 205 X 231 cm. Private collection

PHOTOGRAPHER: DAN OVERTURF

In the next two quilts, I offer a fragmentary glimpse into the scene. In this way, I hope to persuade the viewer to share my insight into nature. I want to use elements that compel the viewer to look again and again, to beckon the viewer to look deeper into the work, to study it and to search for its hidden qualities. This quilt is of an azalea garden and the various creatures that rob it of its beauty.

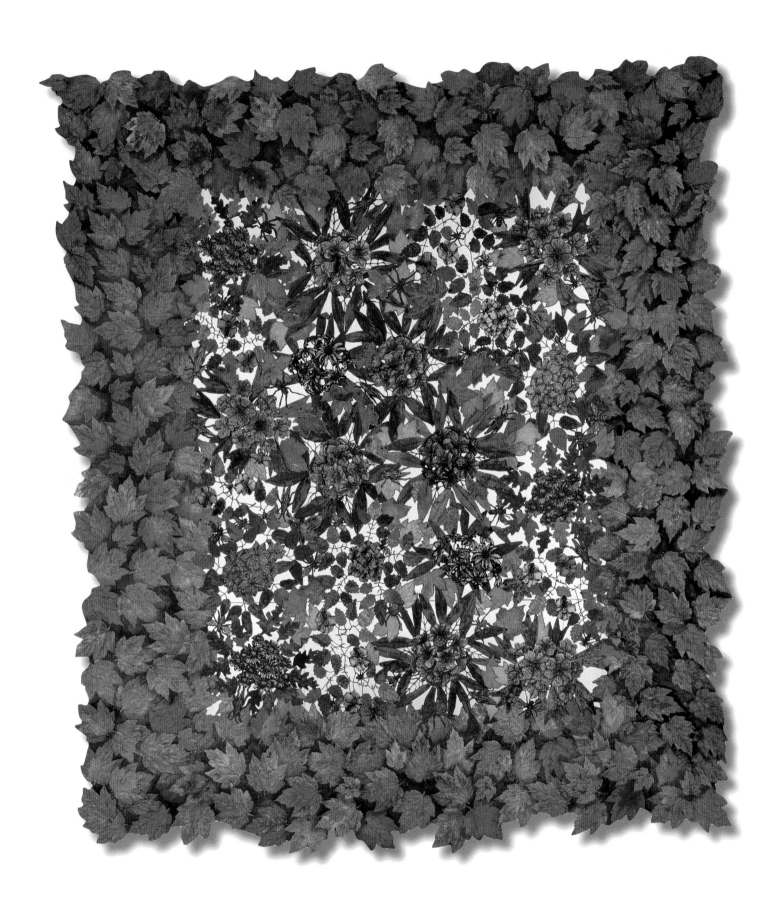

IN THE GRASS

1992. Dyed, screen-printed, painted cotton, appliqué, quilted, sewing machine lace.
93.5 X 99.5 in., 112 X 206 cm.
Private collection

PHOTOGRAPHER: CHRIS MAITZEN

I love gardens and, for me, flowers are the stars of the garden. There is a lot of life in a garden, but there is also decay. During the year as the garden goes from spring to fall there is life in the passage of time marked by growth and then deterioration. In most of my work I rely on motifs from nature in order to illustrate the delicate balance between creation and destruction that is present in all life.

Most of my quilts are large. I need all the space I can get to complete my thoughts between the borders. I want to squeeze every bit of experience into that space. I want to show the beauty as well as the tragedy in the garden. I want to show what the Japanese call wabi. It is a moment of the achievement of perfection before the beginning of decline and decay. It is the beauty of things incomplete, imperfect and fleeting. This is the essential theme of my Paradise Series.

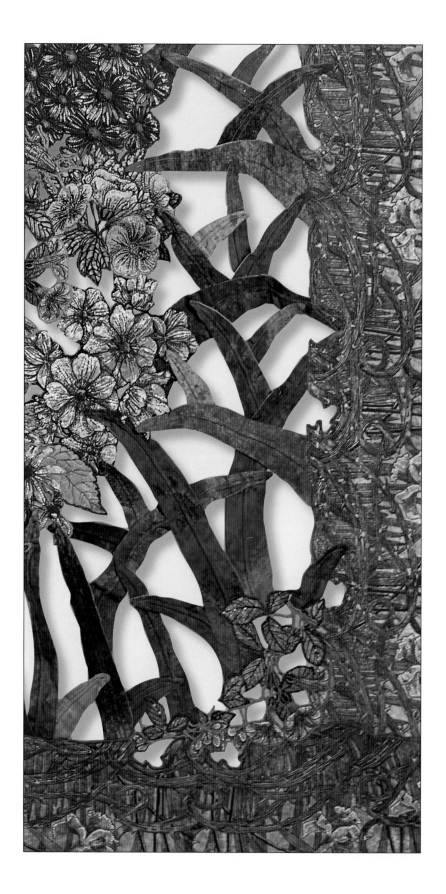

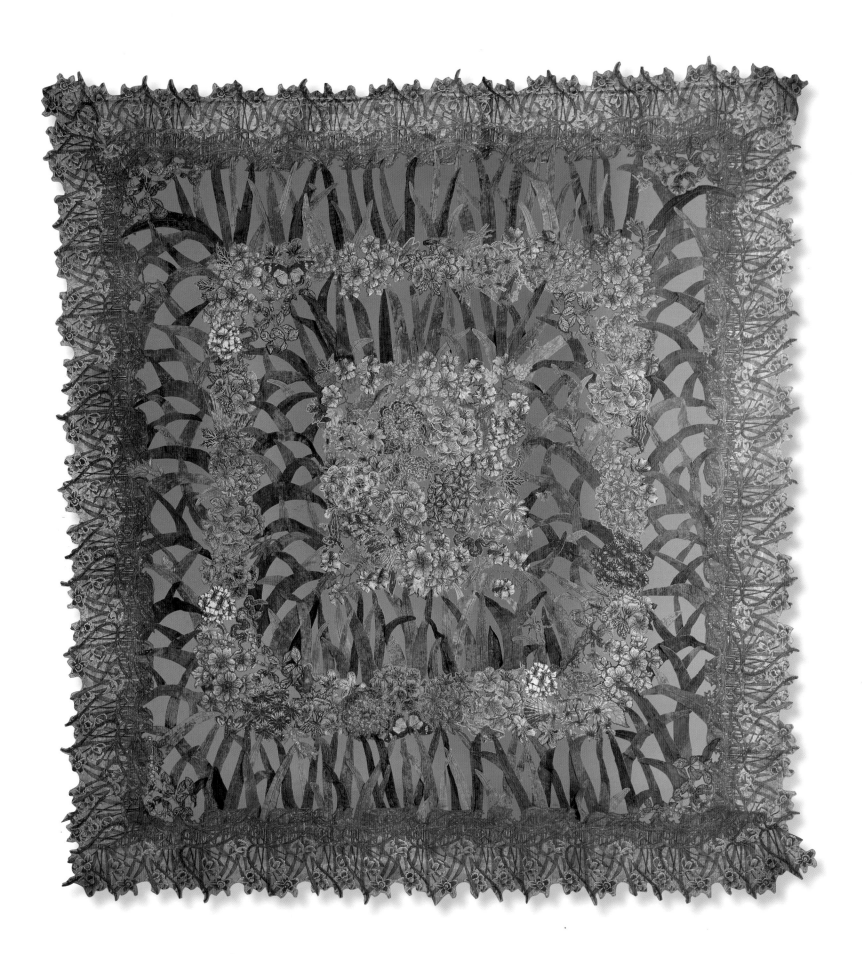

UNTITLED

1969. Poly/cotton, trapunto, 44 X 81 in.,
112 X 206 cm.

Many years ago, I worked in ceramics and
most of my work was white. At that time,
I was changing my medium from ceramics
to fibers. My ceramics were very sculptural
and richly textured. I wanted to achieve in
cloth the same highly textured surface I
had used in clay. I was doing a lot of work
expanding the idea of quilting and what it
did to the surface of the fabric. A quilted
piece made of all white fabrics has form
defined by deep shadows that together
create texture. White can also fool the
eye into seeing colors that do not exist.

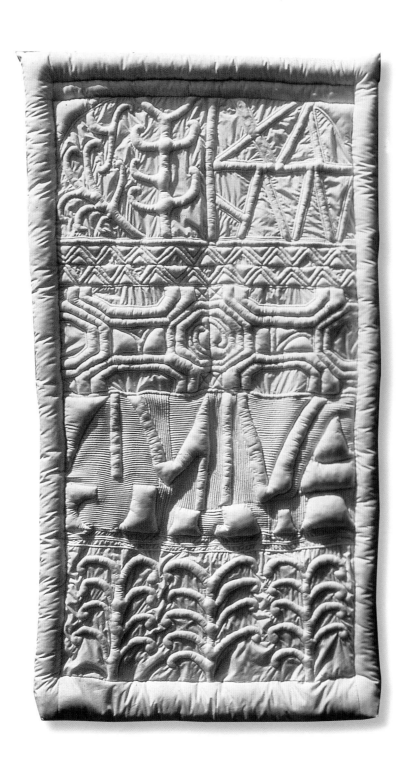

THE GARDEN OF MILK

1994. Screen printed cotton, appliqué, quilted, sewing machine lace. 74.5 X 81.5 in., 183 X 207 cm. Pitney, Harden, Kipp & Szuch Quilt Collection, New York, NY

PHOTOGRAPHER: DAN OVERTURF

When I began my Paradise Series I wanted to construct another white quilt. I wanted to make a delicate, high-contrast quilt using different shades of white. The imagery of this quilt is the fence that enclosed my sister's garden. The title *Garden of Milk* comes from a legend of the Amazon Jungle, where it is thought that a drop of milk from heaven made the first garden.

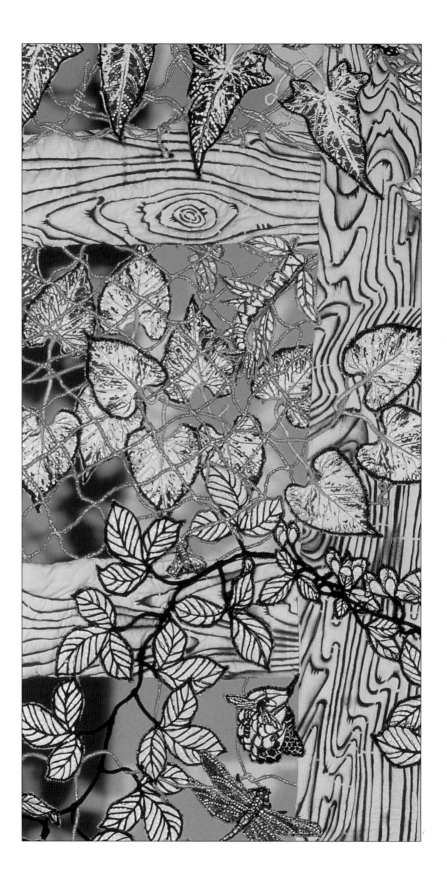

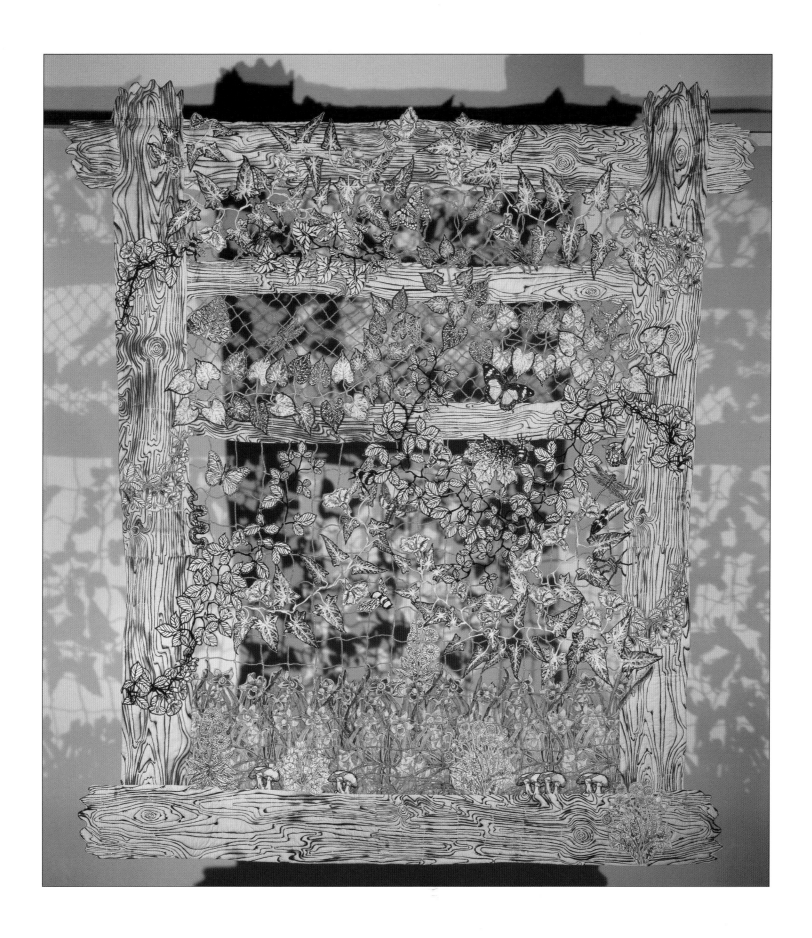

THE OTHER MESSENGERS

1995. Screen-printed, hand-painted cotton, appliqué, quilted, sewing machine lace. 84 x 108 in., 213 X 274 cm.

PHOTOGRAPHER: DAN OVERTURF

Fall is my favorite season because of the multicolored leaves. I have made many pieces that include leaves where I have the desire to line things up and organize them according to color. In this quilt, I accented each joining with an insect. I didn't have a name or plan for this quilt; it simply grew as I constructed it. When I put the leaves together I couldn't step back to view it from a distance since my studio at the time was too small. Only after it was in a museum was I finally able to get a good look at it. I was quite surprised to see that I had made a mandala.

After I finished this quilt, I happened to be looking for my sketchbook. I ran across a sketch that I made for an art class when I was nineteen and was startled to see that it contained elements of the quilts that I was to make thirty-two years later. Work as an artist emerges from ideas that come from the remote places of memory.

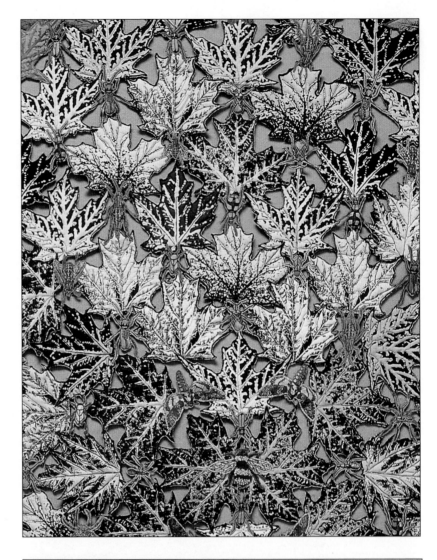

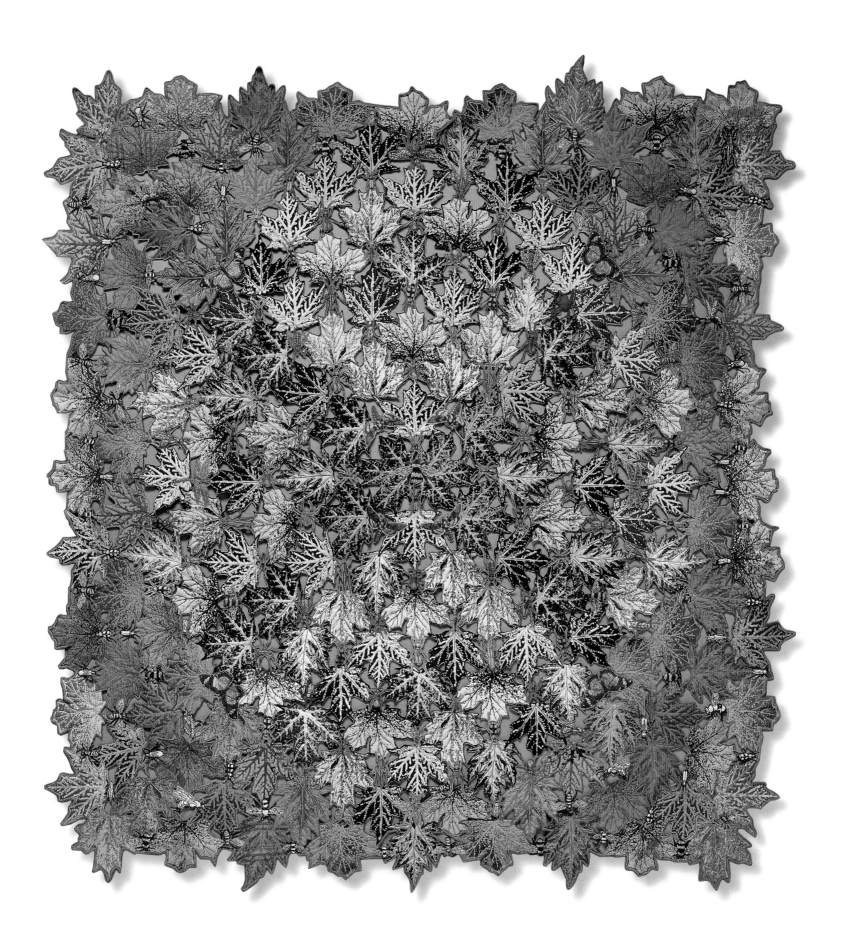

Leaves I:
Springer Street

1979. Printed, cut, sewn, drawing quilted on poly/cotton. 136 X 51 in., 345 X 130 cm.

This piece began as a black and white photograph of the house across the street. The shadows and different textures on the front of the house intrigued me so I drew them on the surface of the fabric. The leaves were printed, cut out and sewn onto the front.

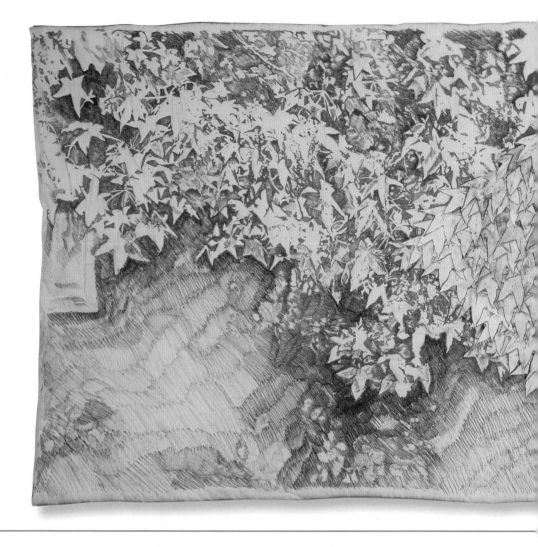

GIVE US THIS DAY

1996. Hand-dyed, screen-printed, hand painted cotton, appliqué, quilted, sewing machine lace. 65 x 70 in., 165 X 178 cm. Private collection

PHOTOGRAPHER: DAN OVERTURF

In museums I always spent time looking at the historical tradition of still life painting. From early Roman wall painters through to the Dutch painters of the 17th and 18th-centuries, the still life, as a subject, was an important means of expressing the idea of abundance. The opportunity to create my own still life by using the shapes and colors of vegetables, insects, fruits, fish, and snakes in my work, and the opportunity to include similar subject and content, is the motivation for creating *Give Us This Day*.

At this time, I was experimenting making lace on my sewing machine so I was inspired to construct lace for the tablecloth.

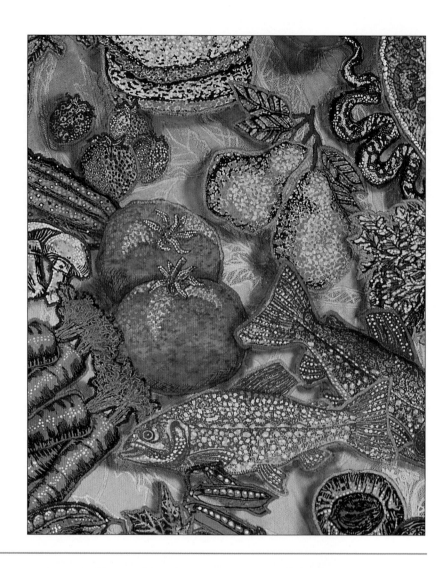

Anonymous Roman painter. Poppea's Villa at Oplontis, ca. 30 B.C. Torre Annunziata, Italy

Anonymous painters. Three small paintings from the Long Corridor at the Yiheyua, the Summer Palace, Beijing, China, 1750, rebuilt in 1860 and 1866. The Long Corridor has been repainted many times.

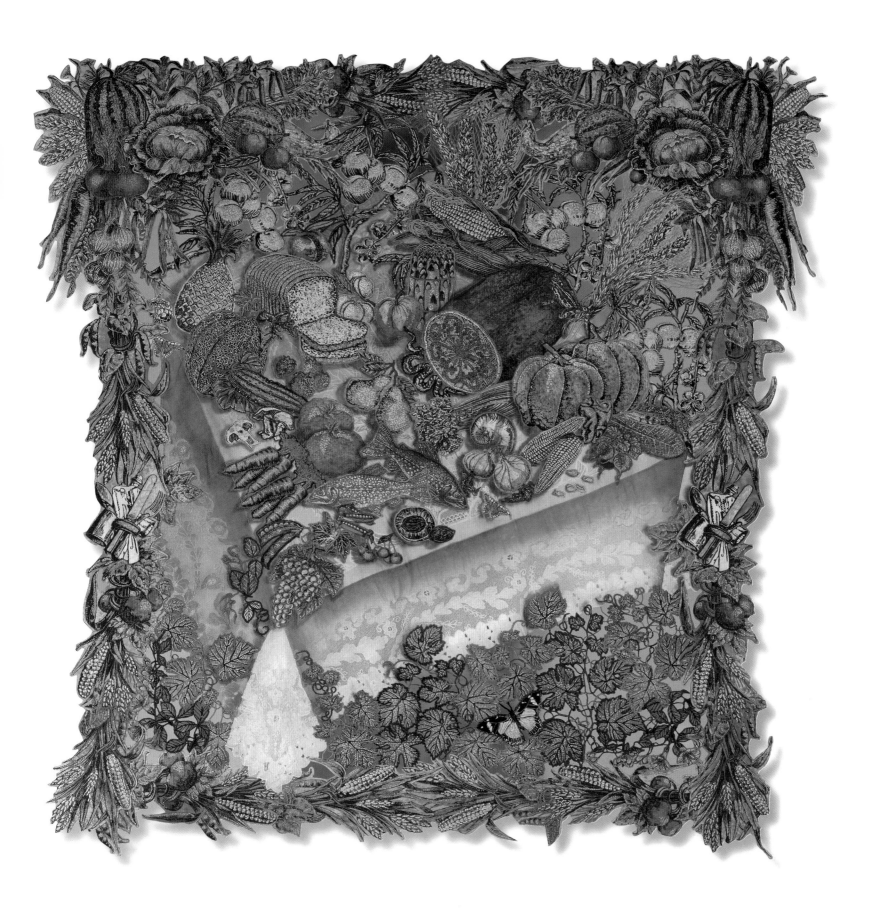

When the Bee Stings

1996. Hand-dyed, printed and painted cotton, pieced, quilted. 87 X 95 in., 221 X 241 cm. Private collection

Photographer: Dan Overturf

This piece is the companion to *In the Grass*; again, it shows a fragment of a detail. I used a honeycomb because not only did it reflect the idea of bees, but it also gave me the opportunity to use its negative spaces.

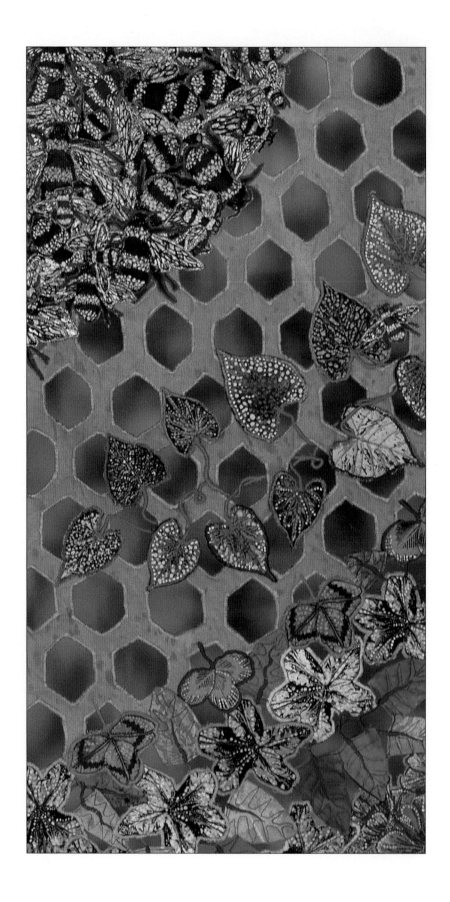

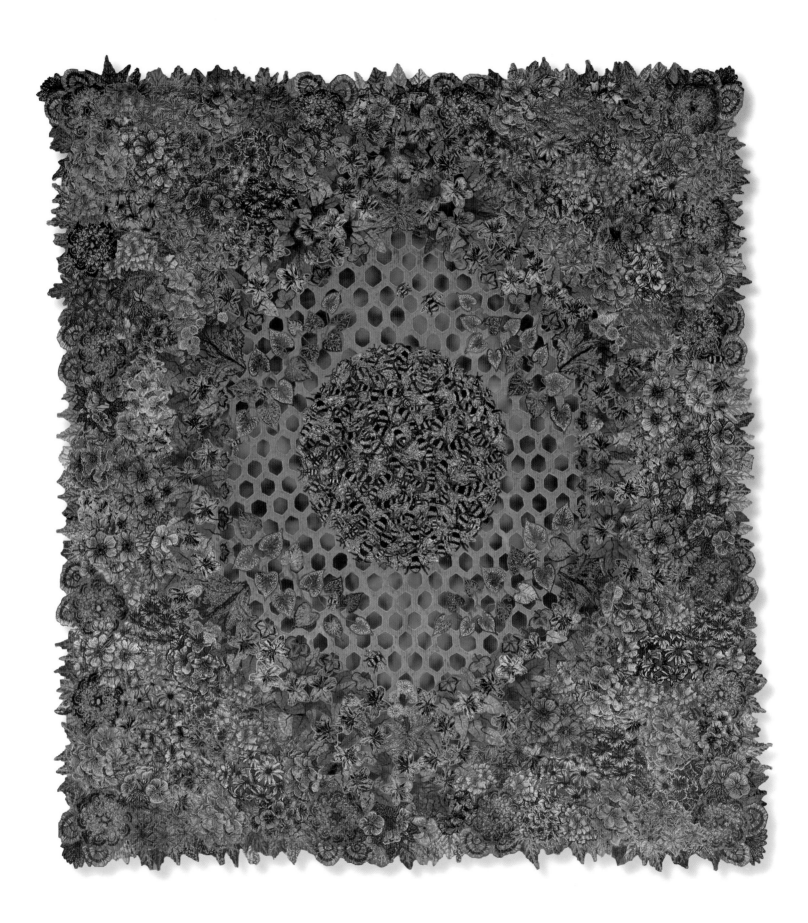

A Riddling Tale

1998. Hand-dyed, printed, painted cotton, airbrush, appliqué, sewing machine lace. 86 X 97 in., 219 X 240 cm. Collection: Illinois State Museum, Springfield, IL

PHOTOGRAPHER: DAN OVERTURF

A Riddling Tale is a quilt that I made in the form of a manuscript. I admire the tiny paintings and illuminated letters in ancient books and manuscripts. In these books the detail of the painting in the borders and the letters that reflect the content of the text are the elements that are most intriguing to me. The use of an airbrush enabled me to make the fabric appear three-dimensional.

I chose an alphabet since it is the basis for a beloved rhyme. As I was assembling the pieces for the quilt, I realized that it started to take on a life of its own as each letter began to tell me a story. Since I have always been delighted by manuscripts, children's stories and puzzles, I became aware that I could engage the viewer, not only by the appearance of the quilt, but also by the forms of the letters and the visual cues that I presented. Each letter of the alphabet has a corresponding image that visually represents its phonetics, and each letter and image suggests a story. The visual imagery in the letters allows the viewer the opportunity to make associations. The squares depicting the numerals "1" through "10" also contain items equaling the amount the number itself represents.

Some of the sections are quite literal, as *A* is for apple, *B* is for bee, *C* is for carrot. Others require a little thinking.

Although I began *A Riddling Tale* wanting to make a manuscript of the alphabet, it ended up being a puzzle.

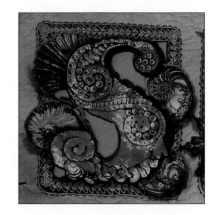

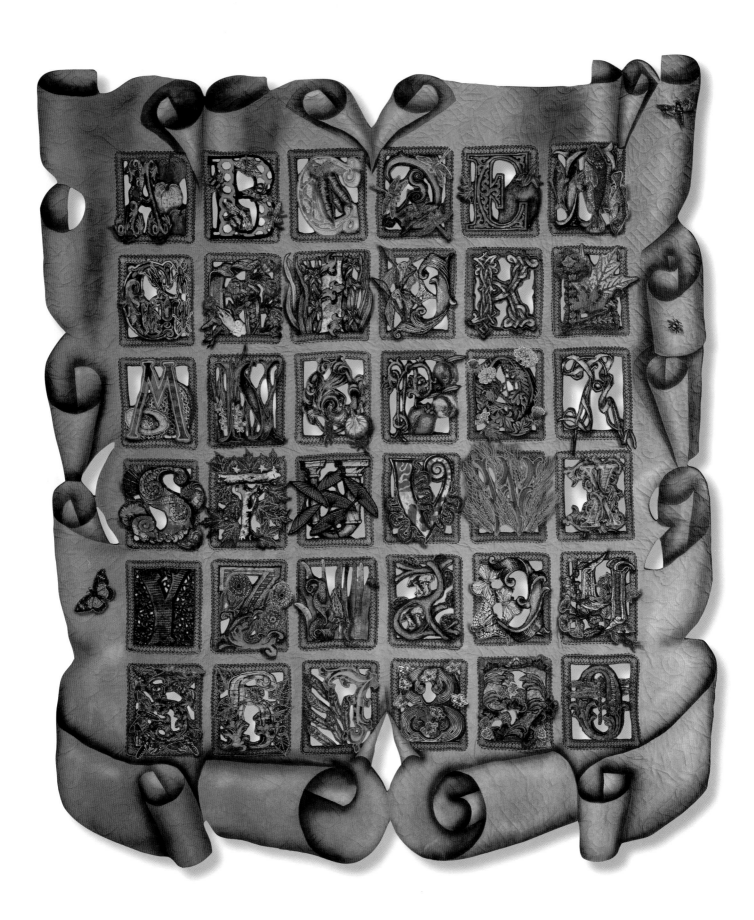

Uncoiling Snakes

1998. Hand-dyed, screen printed, hand-painted cotton, appliqué, sewing machine lace, 65 X 70 in., 165 X 235 cm.

PHOTOGRAPHER: DAN OVERTURF

Uncoiling Snakes symbolizes the legendary "sacred tree" that is represented in all cultures. I used all the conventions that are displayed in Indian Tree of Life textiles; the backward curved, sensuous trunk, the crossing of branches and a variety of species on the same tree. These textiles were rarely concerned with fashion. The most important aspects of these textiles were the symbolism of color and the complex ritual of life.

My quilt alludes to the variety of ways that trees have been revered, including the tree in the Garden of Eden, sacred groves, the cosmic tree, the tree in blue-willow pottery, and even the Christmas tree. It represents the sacred trees that I saw in India and the Japanese Goshimboku, or divine trees. Many of these trees are abundant with fruits, vegetables, mushrooms, insects, birds and snakes. They speak to the sanctity of life as well as the mythological tree as the link or pathway between heaven and earth. This quilt references Indian palampore fabric, the Victorian tree of life quilts, and all other trees that have been venerated worldwide.

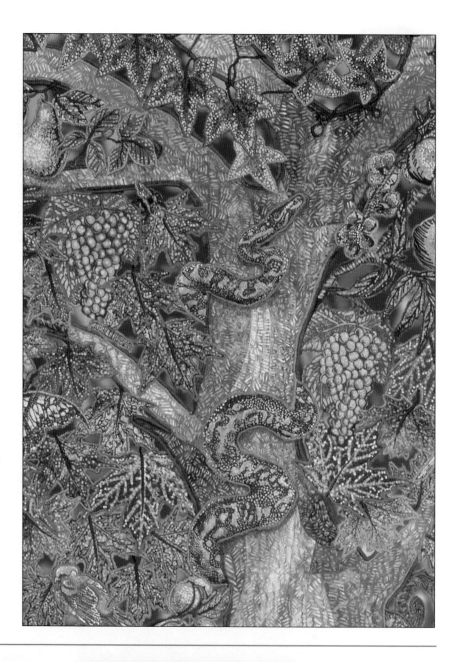

This plate shows the apocryphal tale of the Blue Willow. The story involves two Chinese lovers who were forbidden to marry. They eloped and when they were just about to be killed they turned into a pair of turtle-doves.

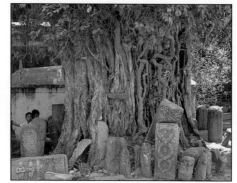

A sacred banyan tree and memorial snake stones. The cobra is worshiped as a nature deity in India. Snakes are associated with water and fertility. Snakes also may signify knowledge and wisdom, probably because they live underground and know the secret places of the earth.

Shri Kalahasti, Andrah Pradesh, India

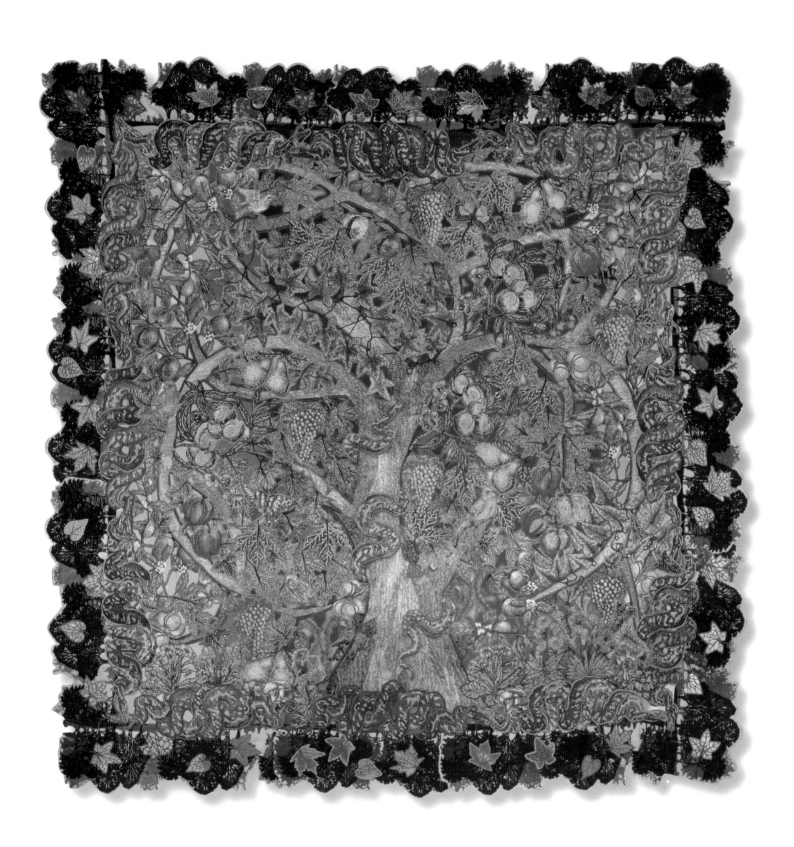

ALPHABET SOUP

1998. Hand-dyed, printed, painted cotton,
airbrush, appliqué, sewing machine lace.
74 X 98 in., 188 x 249 cm.

PHOTOGRAPHER: DAN OVERTURF

Manuscript letters and vegetables comprise
the theme of *Alphabet Soup.* This quilt was
made with the leftover manuscript letters
from *A Riddling Tale* and vegetables from
Give Us This Day. I decided to use them
as one uses leftovers in a bowl of soup.
It has images of all the ingredients in my
soup and was made to remind me of the
good time I had as a child laying out the
letters to spell words and then eating the
soup. The border is decorated with the
negative shapes of letters that spell out a
recipe. There are soup bowls in my favorite
blue and white. There also are references
to a children's song and an old joke.

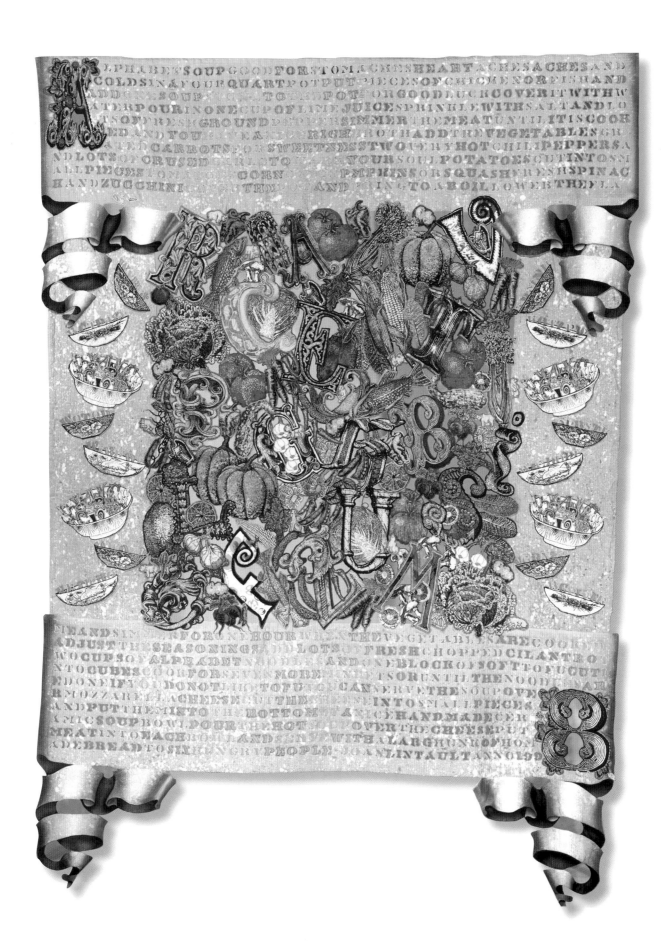

THE THREE SISTERS

1998. Hand-dyed, screen-printed, painted cotton, appliqué, sewing machine lace. 71 X 81 in., 181 X 206 cm. Collection: Peoria Art Museum., Peoria, IL

Inspired by the vegetables in *Give Us This Day* and the possibility of using the color and shapes of vegetables to obtain interesting negative spaces, I decided to make a vegetable garden.

Three Sisters refers to the cultivated gardens of Native Americans. This quilt honors an Iroquois gardening tradition of interspersing corn, beans, and squash together in hills as a way to meet the particular needs of these crops, as well as their people. The beans used the corn stalks as poles, the beans added nitrogen to the soil, and the squash gave shade to the roots. Each plant depended on the other, so this method of planting was known as the three sisters.

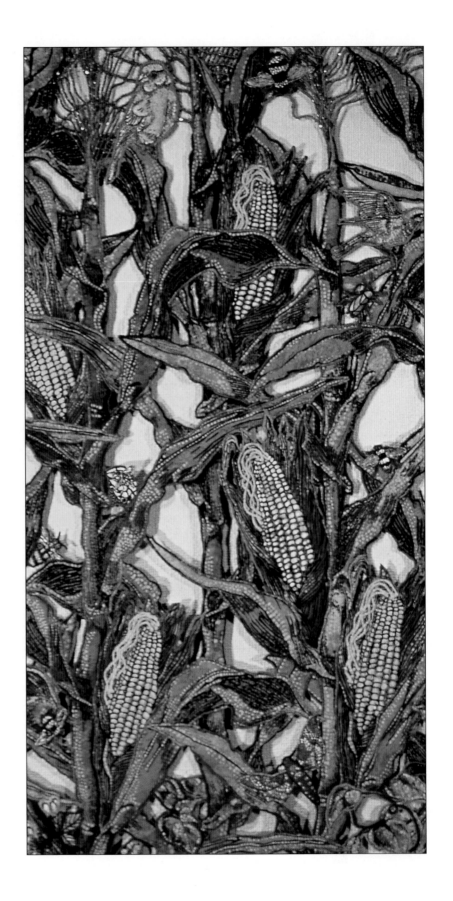

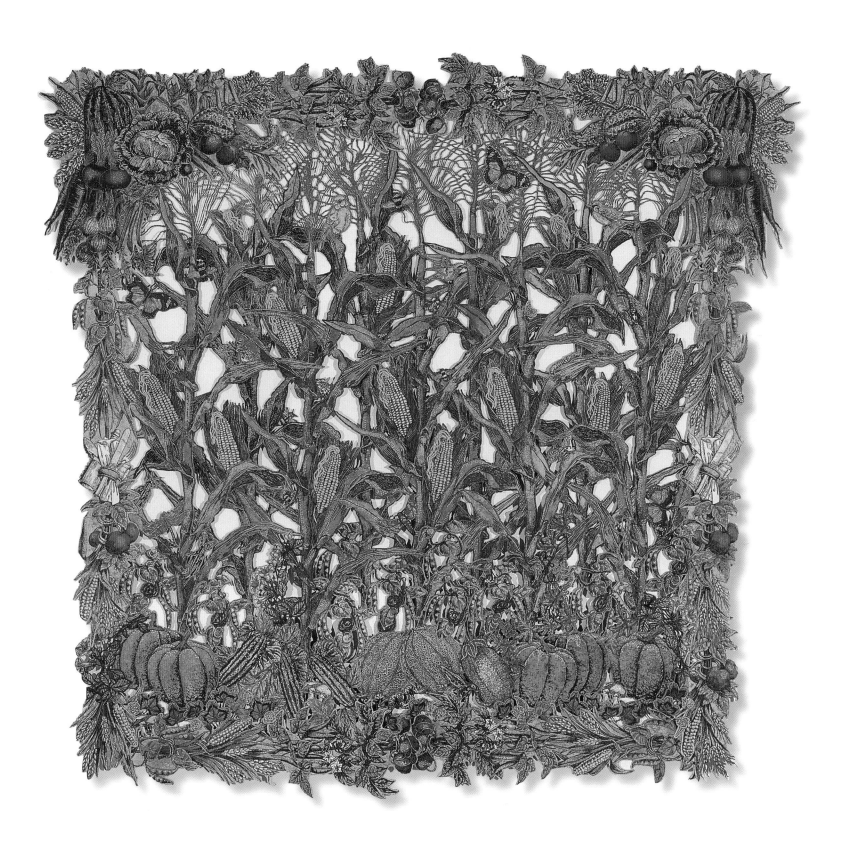

TIME OF THE BUTTERFLY

2003. Hand-dyed, screen-printed, hand-painted cotton. Border is stencil printed with rice paste resist, appliqué, quilted, machine embroidery and sewing machine lace. 65.5 X 68.25 in., 166 X 174 cm.
Private collection
PHOTOGRAPHER: BOB BARRETT

For many years I wanted to design and sew my own embroidery on my sewing machine. This quilt was the first one that I finished. I also used the technique of katazome, a Japanese stencil and dye technique using rice paste as a resist. This technique plus machine embroidery was used for the border.

I called it *Time of the Butterfly* because I wanted the butterfly to be a symbol of the soul, as it was in ancient as well as contemporary cultures. For the ancient Greeks, the transformation of a butterfly from pupa to adult was a metaphor for the soul's resurrection and immortality. The ancient Greeks believed that when people died, their spirits left their bodies in the form of butterflies. The goddess Psyche, as a butterfly, was the personification of the soul represented in ancient Greece.

> *The butterfly the ancient Grecians made*
> *The soul's fair emblem, and its only name—*
> *But of the soul, escaped the slavish trade*
> *Of mortal life !—For in this earthly frame*
> *Ours is the reptile's lot, much toil, much blame,*
> *Manifold motions making little speed,*
> *And to deform and kill the things whereon we feed.*

> —Samuel Taylor Coleridge, 1808

In Mexico, the Aztecs thought butterflies symbolized the incarnation of the souls of their fallen warriors. They are represented by Itzpapalotl, the Obsidian Butterfly. This

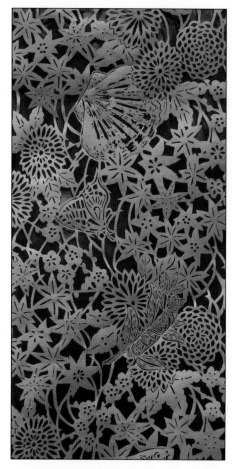 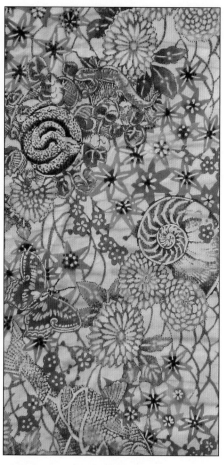

The border for Time of the Butterfly *(right) was printed with rice paste using my hand-cut stencil. The fabric was first dyed blue, and then shibori was used for the next layer. Rice paste was applied. Then it was hand-painted with Sabracron F dye, colored with fabric markers, and painted with Vivitone screen-printing inks.*

goddess is a somewhat darker aspect of the Earth Mother figure and a patroness of warriors. However, for me the butterfly has a more ominous contemporary association. It has been discovered that a butterfly-like pattern appears in the x-rays of individuals who have been killed because of a compression explosion from a terrorist bomb. It seems that the fragile butterfly is a powerful symbol that spans cultures and centuries.

I also wanted to refer to the butterfly effect. The flapping of the wings of a butterfly can change the course of the weather forever. In addition the meaning of eternity can be marked by the amount of time it would take a butterfly to wear down a mountain if it flapped its wings once every thousand years.

Although I didn't plan it, this quilt became my symbol of violence, hope, resurrection and immortality on September 11, 2001.

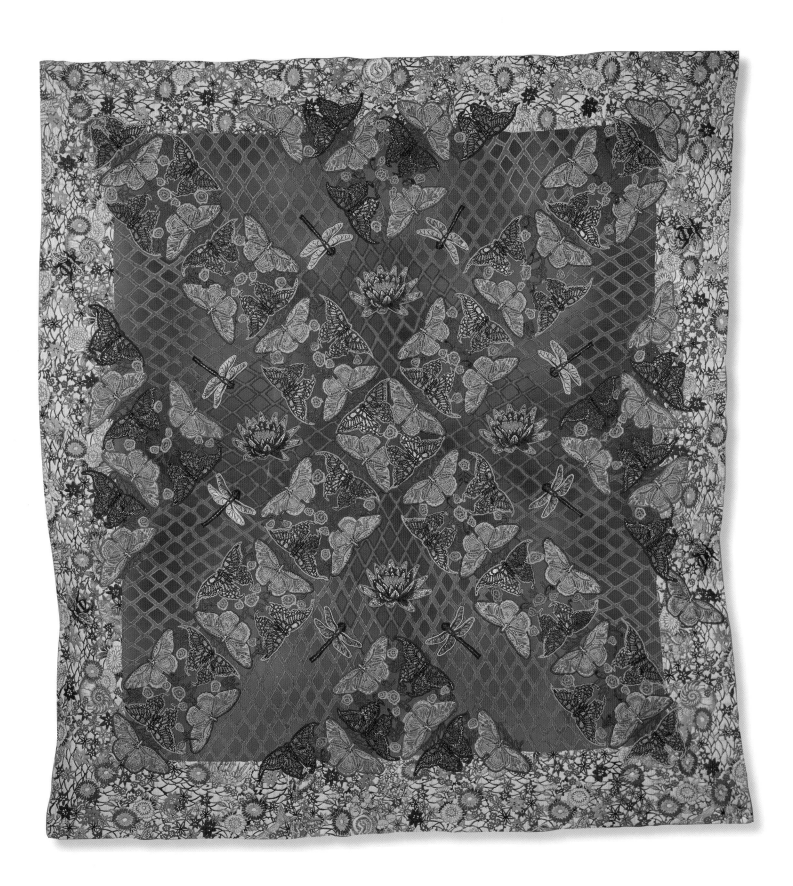

FAN DANCER

2004. Hand-dyed, screen-printed, painted cotton, appliqué, quilted, sewing machine embroidery, 56 X 59 in., 142 X 150 cm.

PHOTOGRAPHER: BOB BARRETT

Fan Dancer is one of my portrait quilts. I am using the idea of portrait and the expressive form of images to tell stories. This piece is about all the dancers and actors that use fans in eloquent ceremony. It is about hiding behind masks, deciding which one to wear and why. The piece also refers to the language of fans, history, false faces, transformation, hot weather, my father who gave me fans, and my aunt who danced with feathered fans.

When I was young I went backstage when my aunt Corrine and uncle Tito Valdez danced at theaters in New York City, during the time when there were live performances at the Paramont, Roxy, and Radio City Music Hall. There I learned the importance of camouflage, concealment and the meaning of artifice.

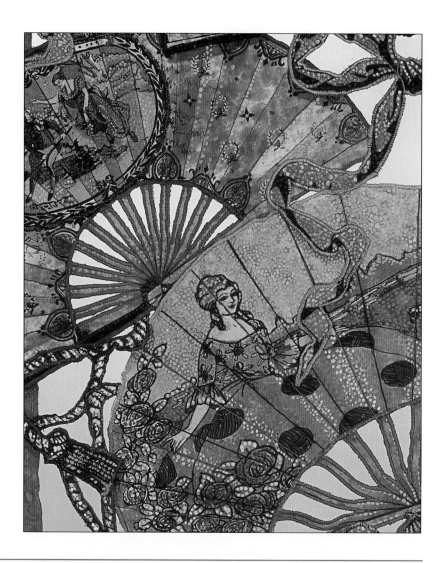

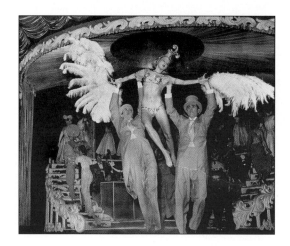

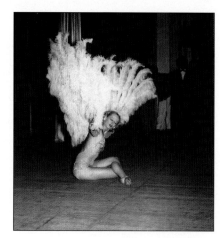

My aunt, Corrine Valdez, at The Latin Quarter, 1950.

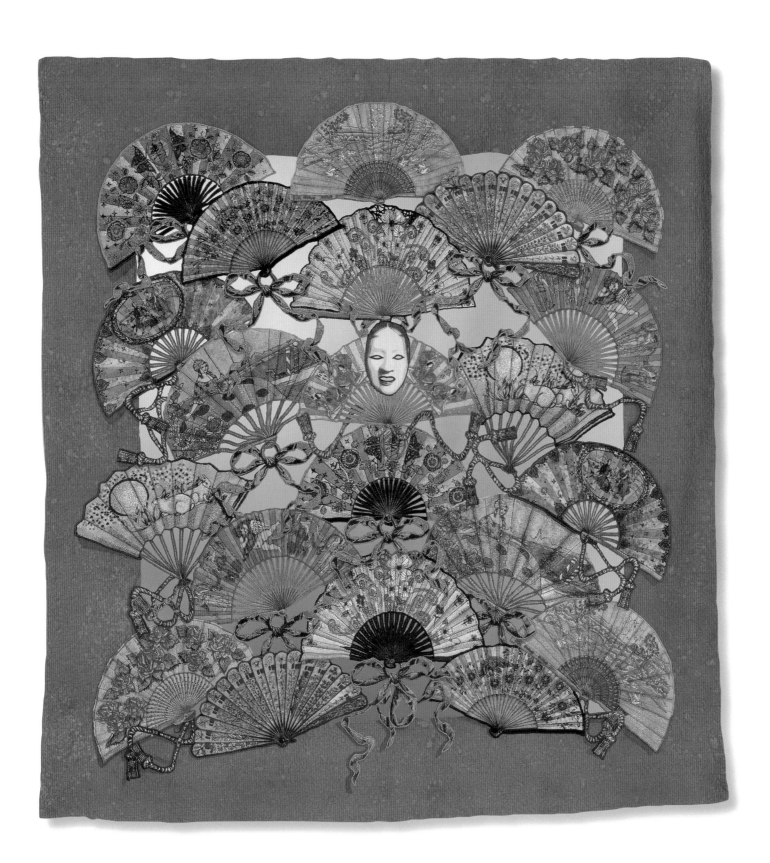

THE MIDDEN

2005. Hand-dyed, screen-printed, painted cotton, appliqué, quilted, sewing machine embroidery, sequins, beads. 57 x 60.5 in., 145 x 153 cm.
PHOTOGRAPHER: BOB BARRETT

The traditional meaning of the word midden is a refuse pile marking a rubbish site or garbage pit. This quilt is also a portrait quilt. I have lived many places where garbage is valuable. Since then I have never looked at garbage the same way again. I wondered if I took pictures of garbage in every country would it be possible to determine where I was. Small slices of phenomena can show us the importance of small and hidden things. Archaeologists can tell us something of the past by looking through the layers of a midden.

For over 25 years I've collected my broken dishes. Each shard showed a fragment of a pattern and was precious to me as it represented a cup, teapot or dish that had existed in a specific time. These fragments retained a dignity that I never noticed while the cup or plate was whole.

I picked up a lot of shards from a beach in Okayama, Japan, a kiln site in Korea, and along the road in Dolores Hidalgo, Mexico. If the edges were rounded from water or dirty from the road that also became a part the story.

I designed the knives, forks and spoons and embroidered them with my sewing machine. As a small child I always wanted to make a story, so I thought that the men were knives, the women, forks and the children were spoons.

Cutout letters of Anthony Thwaite's poem *Archaeology* are used around the outer border of this quilt.

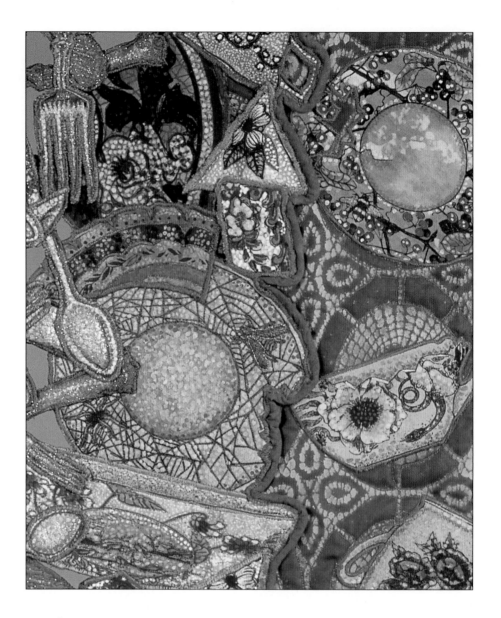

ARCHAEOLOGY

How would it be if we remembered nothing / Except the garbage and the rubbishing. / The takeaways, the throwaways, the takeovers, / The flakes and breakups, the disjected members / Scattered across the landscape, across everything?

Nothing stands up, nothing stands clear and whole. / Everything bits and pieces all gone stale, / All to the tip, the midden topped up high / With what we used, with what we threw away: / How would it be if this was all we could feel?

That will not be. Remembering, or feeling, / Or knowing anything of anything, / Will be the last we know of all this stuff, / It will be there for others, seekers of / Things that remain of us, who then are nothing.

—ANTHONY THWAITE

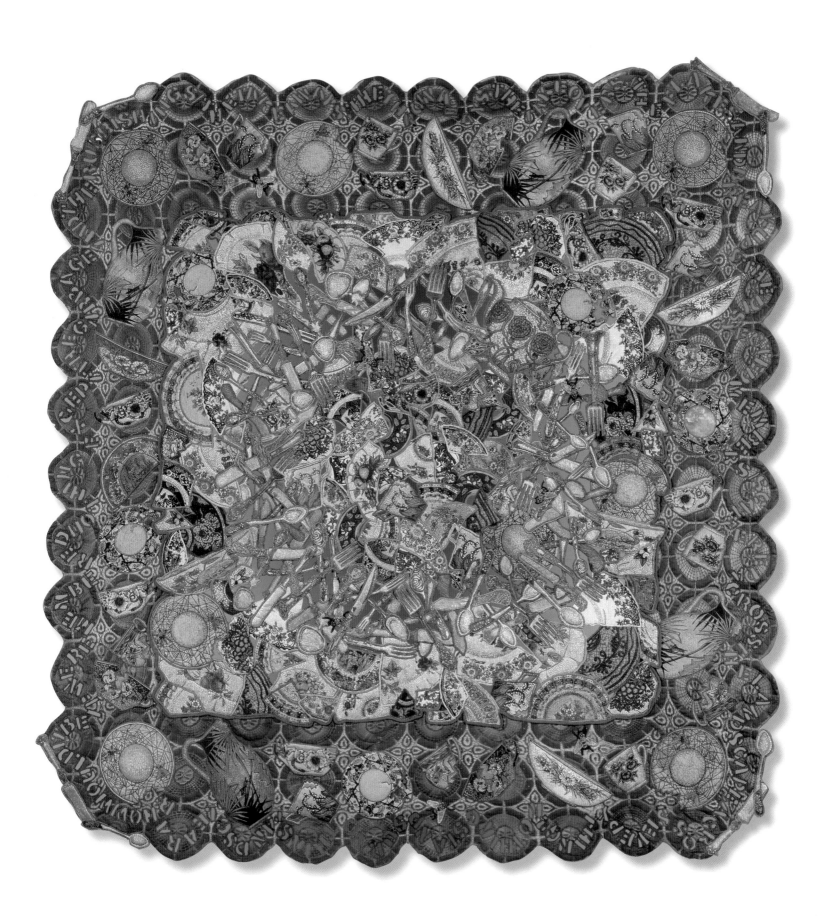

TOWER OF BABEL

*2007, Hand dyed, screen-printed,
hand painted cotton, appliqué,
quilted, sewing machine embroidery,
40 x 45 in., 101.5 x 114 cm.*

PHOTOGRAPHER: KIMBERLY KOLOSKI

The story of the *Tower of Babel* is from the
Book of Genesis. The people of Babylonia
decided to build a tower that would reach
into heaven. It was an enormous enterprise
requiring cooperation among people who
all spoke the same language. The tower was
built with the intention of exposing man to
the mysteries of heaven and the greatness of
God. After a while, God disrupted the project.
He thought humanity was arrogant to at-
tempt such a tower. To make it impossible
for the workers to communicate, he caused
everyone to speak a different language.

I made this quilt because of all the differ-
ent languages I don't understand in the
many countries I've visited. I also can't read
music, comprehend calculus, chemistry,
spoken or written Japanese, Arabic, Chi-
nese or Hebrew. These are the mysteries
in my *Tower of Babel*. Visually I can appreci-
ate the beautiful fluidity of line and use
of space of all these written languages.

I want to give the English alphabet
similar visual impact. I used sewing ma-
chine embroidery to give the letters
texture. I also used various sizes of let-
ters and handpainted each letter to fur-
ther enhance and accent the shapes.

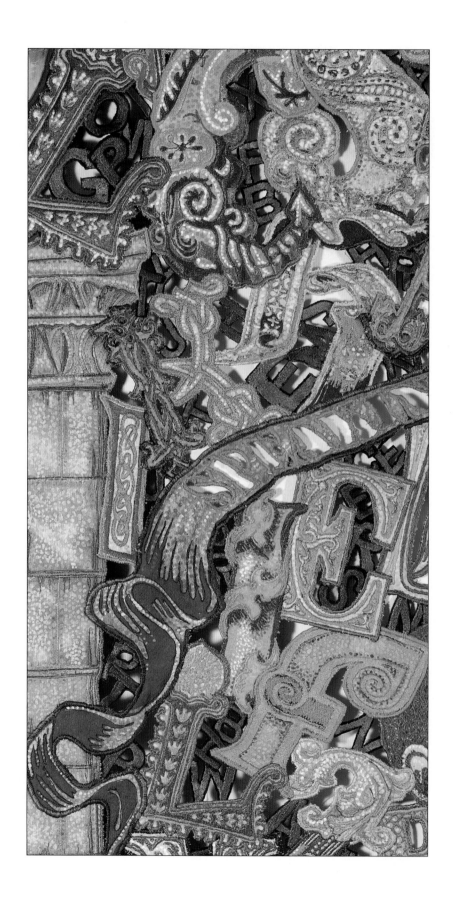

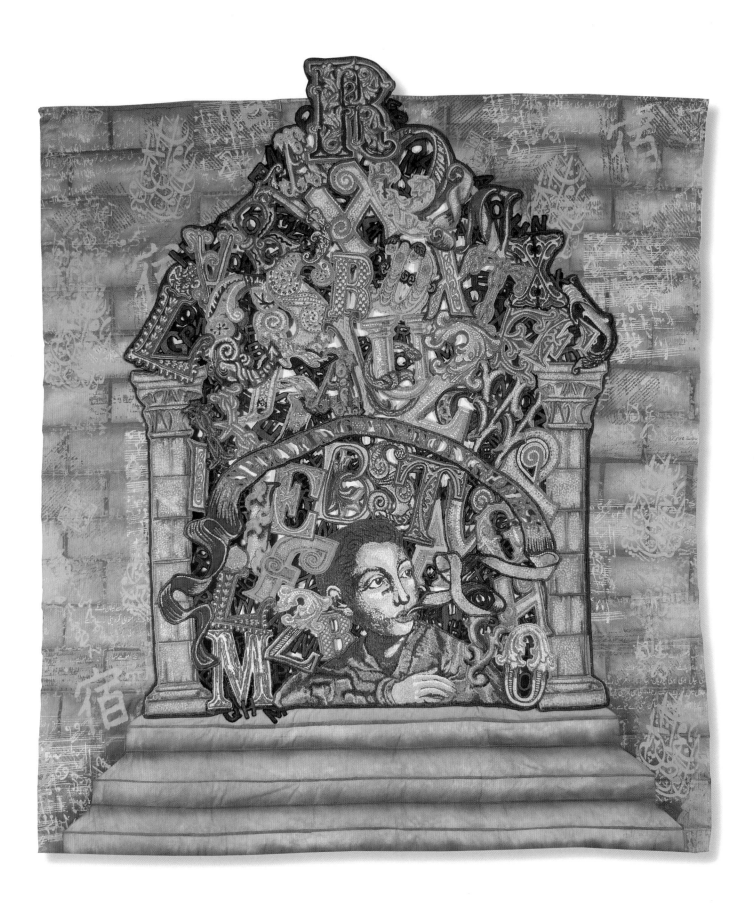

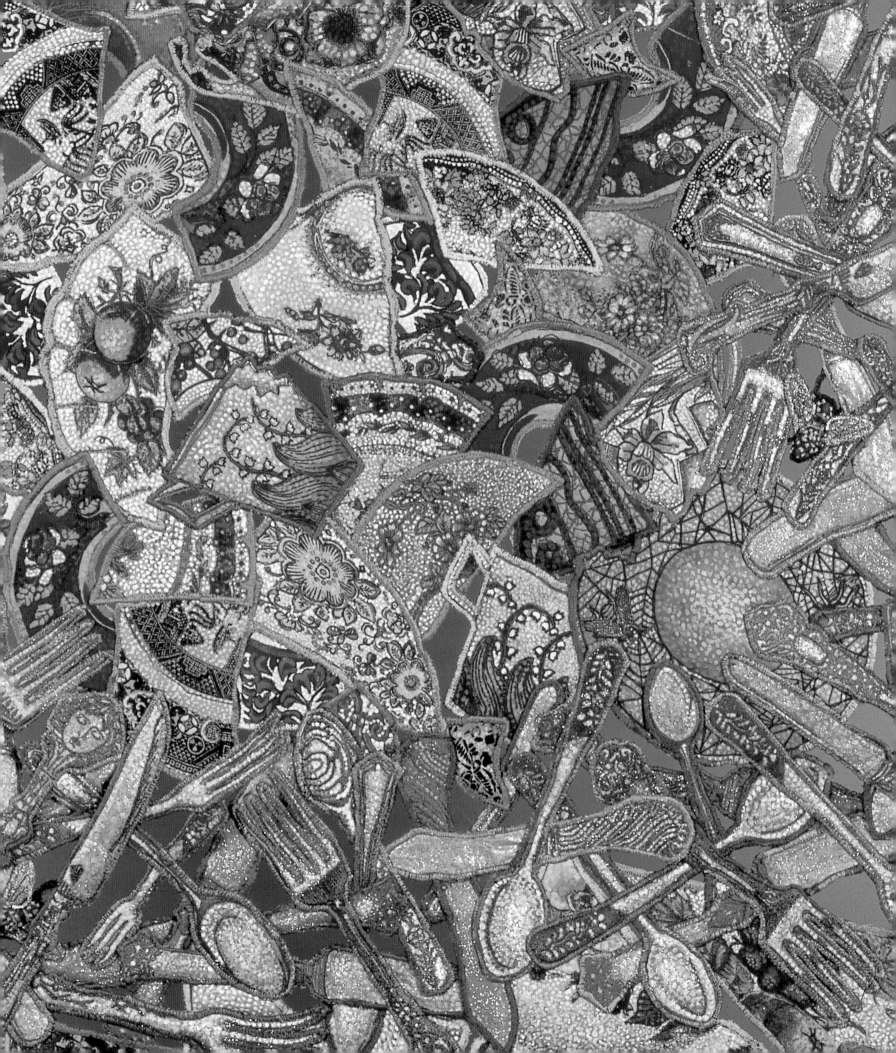

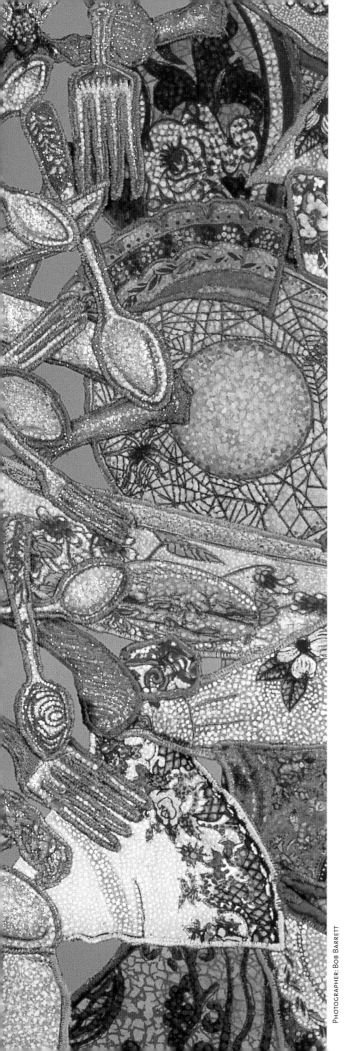

Photographer: Bob Barrett

Six Impossible Things
Before Breakfast

Alice laughed,
 "There's no use trying,"
she said,
"one can't believe
 impossible things."

"I daresay you haven't
 had much practice,"
 said the Queen.
"When I was your age,
 I always did it for
half-an-hour a day.
Why, sometimes
 I've believed as many as
 six impossible things
before breakfast."

—Lewis Carroll,
Alice in Wonderland, 1865

Peter Watson in his book *Ideas: a History of Thought and Invention, From Fire to Freud* says that ideas do not come from daydreaming but from working very hard and having many failures. Ideas come from other ideas. You can not go from nothing to a great idea without doing a lot of work. I think the interesting thing in life is not having an idea, but realizing it.

I also say there are no new good ideas. "Good ideas" come from previous work. When a person says, "that's a good idea", they have no clue to the influences and forces that took you to this place.

Creative thinking involves the productive use of our powers as artists. We as artists create impossible things. The question is not why do some people appear to be creative but why others seem not to use the creative ability with which they were born. Nature is creative, constantly changing and forming new variations. Humans have similar genetic imprints and also the ability to form new and original patterns. Creativity is a state of mind and is expressed by a childlike wonder to see everything in a new way. One has to constantly confront the environment and make new discoveries, connections and inventions. Do not conform and allow repetition of experience to cause a loss of wonder.

All the material things of life that surround us have been created, invented or made by someone else. This creativity distinguishes the world we live in. This applies to our physical environment as well as our mental one. Our mind is filled with signs, stories, myths and symbols originally formed by other creative people. Many patterns are nothing more than ideas formed by creative persons who found new combinations for quite simple and ordinary things. New is a relative word in the sense that an idea already held by someone else can still be interpreted in a new way.

We as humans have similar genetic imprints and therefore our work will reflect a collective memory, the threads that have been dropped for us to discover. The purpose of the artist is to make new connections between these inherited threads in the form of images, materials and techniques and to make new decisions. A particular image may be evoked by something in one's own life, or by the use of materials that also may pick up on the larger spread of collective memory. The more of these inherited threads that are present, the more the viewer can relate to the work of art. The way a particular artist uses the image becomes that artist's individual vision. What makes a work of art timeless is its ability to communicate and be interpreted in many ways over many years.

Many believe that it is possible to learn about art by taking workshops and learning various techniques. I don't agree. I believe it is important to take art classes and study the works of contemporary artists, as well as artists from other periods. To be able to see the nuances in works of art and how they are defined and interpreted artistically is vitally important to the development of an artist. The more a particular creator has managed to have a real dialog with deep human patterns, as well as the basic images and shapes that recur over time, the more timeless the work. Ideally, we hope that at the work's deepest core it will endure. How do you as an artist find your individual step in this never-ending dance? You as the artist working in a particular time with a special way of creating may bring a new look to an archetypal image that hasn't been present before.

If research on the history of art, fibers and textiles is not done or effort is not applied to the process of creating, then it will be difficult to connect with the continuum. The only threads that will be picked up are the safe ones that are taught at workshops, by teachers, and by quilt groups. Infection by a meme can be the result. A meme is a terrible mind infection; it is a contagious idea that replicates like a virus that is passed from mind to mind. An idea or information pattern is not a meme until it causes someone to replicate it, to repeat it to someone else, and then on forever, constantly folding in and referring to itself. But how do we tell if we have been infected by a meme? If working with constructed textiles such as quilts is to be considered serious art then there should not be a constant replication of the same themes, construction techniques and re-worked ideas that are learned in workshops and constantly entered into exhibitions.

The history of textiles is especially rich and diverse. American fiber artists, while forging ahead with new techniques, new ways to use materials, and developing new ideas, have always worked with one eye cast on the past. The past is the benchmark by which to assess the future.

Within this quest the artist can engage in a cultural transformation by processing techniques from older cultures and metamorphosing them into twenty-first century works of art. The artist takes the old and makes it into a radically different

form, composition or state, transforming the old in spirit, structure, and material. The minimalism of the 60s and 70s did not contain any reference to anything outside itself, whereas the art of the last decade has been heavy with references.

Fiber artists have crossed the frontiers of modern technology, creating new classifications within the long and evolving history of the fiber arts. They have expanded the definitions of this art movement by their constantly evolving forms, by insistence on an art of ideas, by their knowledge of history, and by refusal to turn their backs on tradition.

We must look back to history to see where we came from as textile artists, but at the same time it is important to understand that new work comes from the experience of working. No form of art exists only in the mind as a mere idea. Art takes shape in material. We come to know by our artwork what we think and how we work. We may not know the final outcome or where we will go with our work although we set the course. Our vision, the way we are led along, is through the material, the progress and the process of our work. We have plans and a blueprint, a shorthand view of the material and its treatment. But the finished work is still a surprise. As we work, the piece itself can define or redefine the next step or the step after, combined with some vague idea we might have. We must get involved in what's happening and be completely free to let something go and change. Answering questions means more questions. We listen to the voices of society, culture, to the yes and no of our material, our rules and our time. We

meditate on the unearthly beauty of mere things when isolated from the utilitarian context and rendered in and for themselves.

Engaging in the process of working involves a combination of elements that will transform in time to form something new. When you have reached the point that your abilities have met your ideas, then you have conquered the material. When one is able to work with intensity, losing the sense of time so you do not have to worry about issues of technique or the elements of art, you have entered the altered state of being known as working with a sense of flow.

While working, there must always be a challenge involved, an element of risk. But the main point should not be mastery of technique over content because that will make you a mechanic, a craftsman in the traditional sense. The language of art is obtained through the process of working. Handling materials and working with them is the familiar way into a project. The issue is to make art—not manufacture art.

David Pye in his book, *The Nature and Art of Workmanship* states:

> "If I must ascribe a meaning to the word craftsmanship, I shall say as a first approximation that it means simply workmanship using any kind of technique or apparatus, in which the quality of the result is not predetermined, but depends on the judgement, dexterity and care which the maker exercises as he works. The essential idea is that the quality of the result is continually at risk during the process of making; and so I shall call this kind of workmanship 'The workmanship of risk': an uncouth phrase, but at least descriptive."

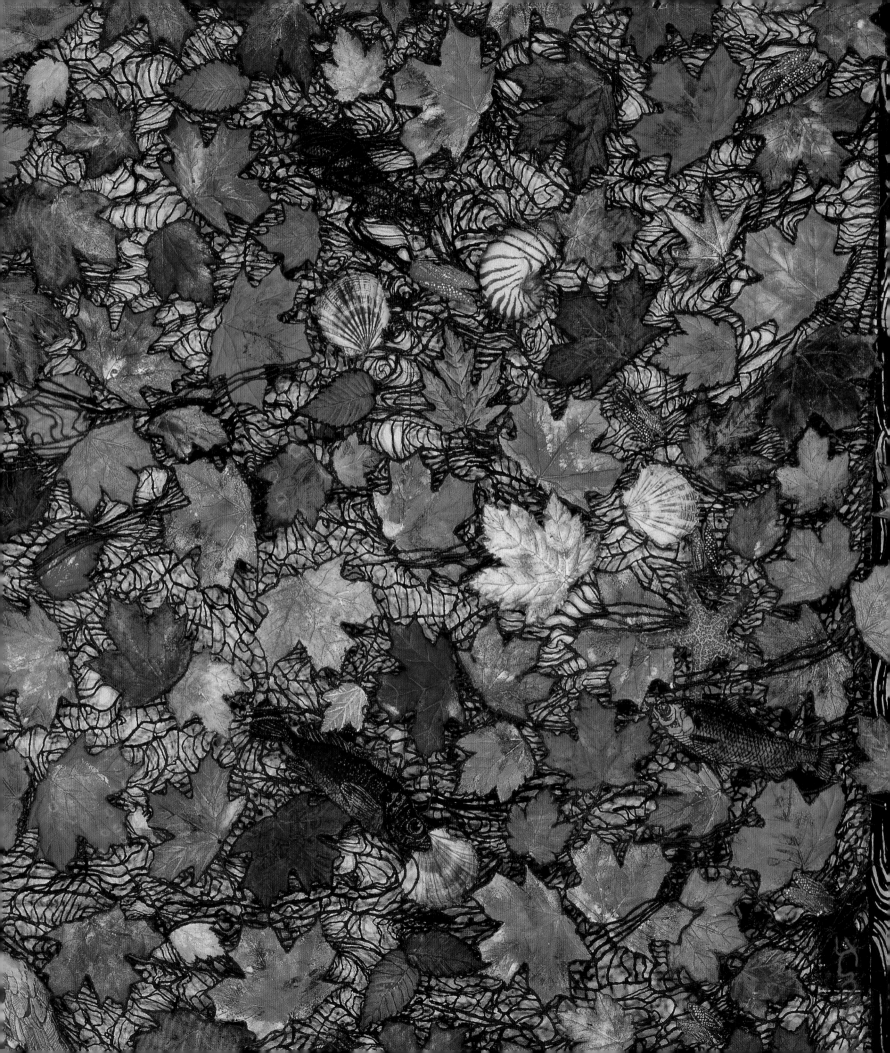

Magic of Light,
Mystery of Shadows

"There are a good many roads here,"
observed the Shaggy Man, turning slowly
around, like a human windmill.
"Seems to me a person could go
'most anywhere, from this place."

—L. Frank Baum,
The Road to Oz, 1909

Alice thought to herself,
"I don't see how he can
ever finish if
he doesn't begin,"

—Lewis Carroll,
Alice in Wonderland, 1865

HUNTING AND GATHERING:

MARKS, FRAGMENTS, PATTERNS, PIECES, PATCHES, RAW EDGES AND SEWN BOATS

All my life I have known the importance of first-hand research and its influences. I always look beyond or through the work toward the theatrical, theoretical, historical or social contexts, finally to arrive at what inspires me about the work.

I have been watching craftspeople work since I was a little girl.

I sat in my grandfather's shop for hours watching him make cigars. The economy of motion and the step-by-step processes of making something always impressed me; the way one step followed another until the final result was achieved.

I watched my grandmother sew. There were patterns, a dressmaker's mannequin, pins and fabric scraps made into bundles. I loved the little bundles. They were mysterious. I often wondered why she packaged them up so neatly.

My work has been influenced by constantly looking and thinking about art, my travels, and watching people work creating their art. My greatest honor was to be in the Peace Corps (1963-1965) and to be able to assist craftsmen in Peru weaving, spinning and dyeing with synthetic and natural dyes. At this time I learned a lot about color and natural dyes.

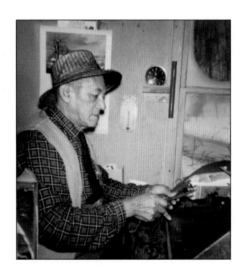

*My grandfather, Gaspar
Garcia, making cigars*

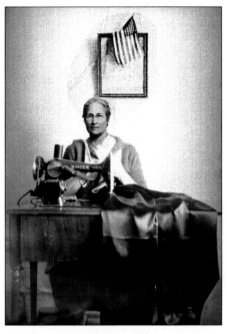

*My grandmother, Maria
Atanasia Garcia Y Fuentes,
at the sewing machine*

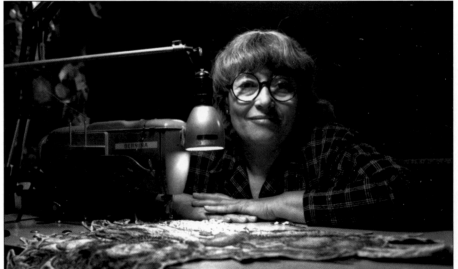

Author at the sewing machine, 1997

PHOTOGRAPHER: JEFF GARNER, UNIVERSITY PHOTO COMMUNICATIONS, SIU-C

In 1979 I decided that I wanted to know more about the textiles and techniques I was teaching. I wanted to know more about the history of processes and designs and also to watch craftspeople in their surroundings. So I decided to find out. I went to India. There I visited embroiderers, weavers, kalamkari painters, block printers, natural dyers and bandhani (tie dye) craftspeople.

In 1983 I spent a sabbatical semester in Japan. I returned on a Fulbright research grant in 1984-1985. During my many visits to Japan over the years, I visited potters, weavers, natural dyers (kusaki-zome tree and grass dyes) and katazome (stencil) craftspeople. Most had learned a process that was passed down through their family or learned their skill by working as an apprentice. Most of them worked with traditional materials. It was enlightening to watch craftspeople who learned their skill from a master craftsperson or their family. They worked with specialized tools and little wasted time and motion.

I respect the intensity that Japanese craftspeople bring to their work. I want to emulate that intensity and the underlying feelings that are present in Japanese art. But I would never want to copy that work only to capture a similar intensity, feeling, depth, and use of symbolism.

In Peru and India I marveled at the accomplishments of people who do something with what they have around them. From these artists I was able to see things through the eyes of others. In ancient societies and cultures, life is simple, yet complicated. In these places I learned how to be flexible. I learned new techniques and learned how to improve the techniques I already knew. I learned the why and why not, of life, existence and art.

I often use my camera as my sketchbook. My photographs are a conversation with myself. How these photographs evolve into a quilt is a personal process where there isn't any formula.

I simply document commonalities and make connections. I am intrigued by minutiae, by the small slices of things that often predict what the larger view would be. Details are very important to me. I love imperfection, the worn and the things with patina or rust. In the West, we have this appreciation but only in connection with the care that we give antiques. However, in Japan I learned that it means more than that. It is a form of aesthetic and a poetic melancholy as found in a rusty iron kettle and worn wood. Finding perfection in random imperfection draws me in.

I document negative space, shapes, fragments of things, marks made by nature, light, time, change, water, adaptation, wrapping, sequence, and repetition—the marks made by constant use that are usually disregarded. When I frame a scene with my camera I am careful to include the formal aspects of line, form, color, texture, light, shadow, space, shape, and pattern. Although it would be hard for someone to say that any particular image is in any one of my quilts, this exercise is very important to me.

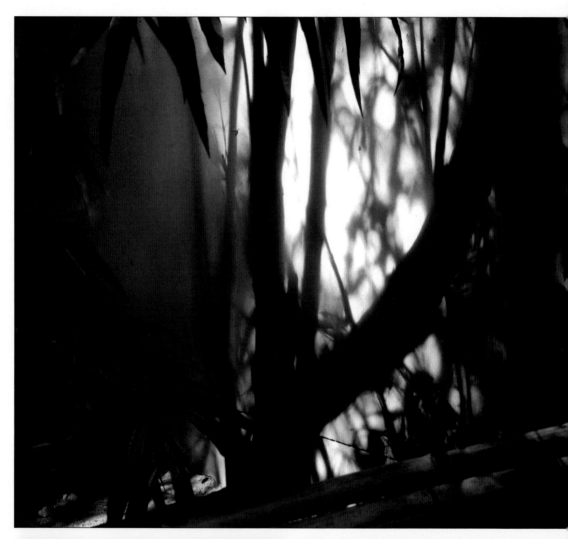

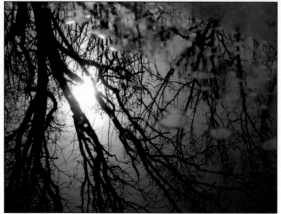

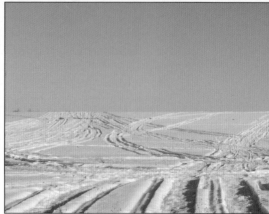

It is the crazing in glazes, weathered wood, and the fragmented placement of pattern that I photograph. The look that comes to a thing after long and loving use. The patched object that is made useful again excites me. There is sadness having a beautiful object that is cracked or damaged and therefore useless. It makes me want to be able to make them complete again by repairing, patching or sewing. This embodies the Japanese concept of sabi, the embracing of flaws.

On the other hand, I photograph snow for its ability to hide flaws, change form and obliterate details. When things are covered with snow, the edges are softened and all blemishes are erased, the structures are accentuated, spaces are enhanced and the shapes are magically transformed into new and pristine forms.

Wrapping trees and hanging fabric in Japan and furniture in India create mysterious bundles that also emphasize form.

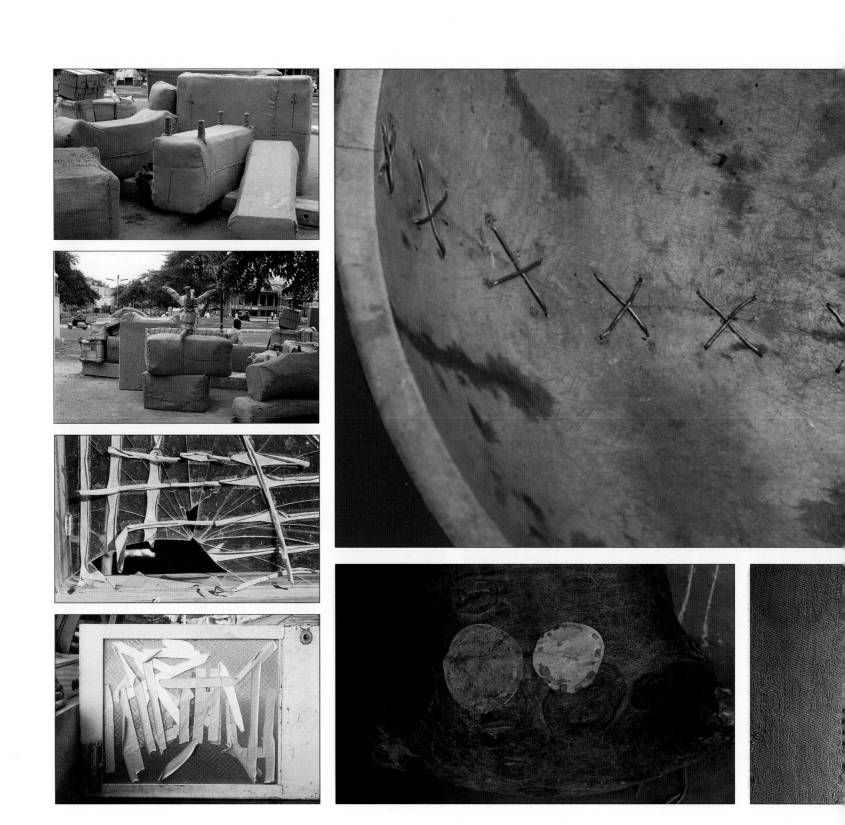

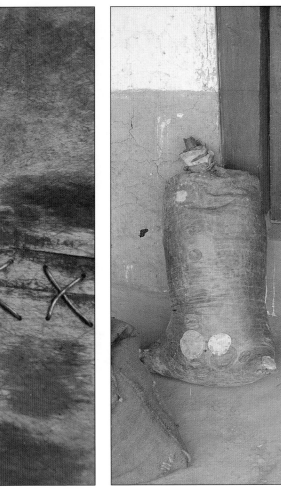

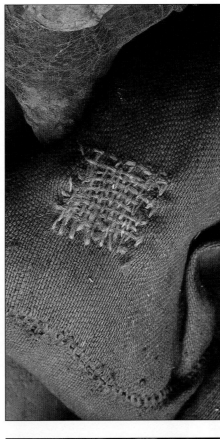

The act of mending, patching and restoring combines elements in innovative ways and creates a new object without losing some of the qualities of the old. These objects show the scars, wounds and patina that come with time and the abrasions they have suffered since they were made. This gives them a dignity and pathos that they did not possess when originally made.

saw impossible things, such as these sewn boats on the beach in Puri, Orissa, India. I love the rough sewing and the energy it conveys. These wooden boats are sewn with coir (coconut fiber) ropes and caulked with plastic bags. I realized I was seeing something remarkable, and that anything is possible.

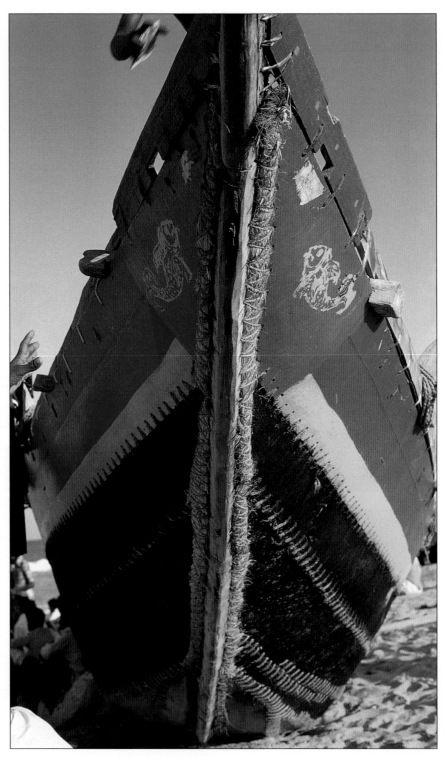

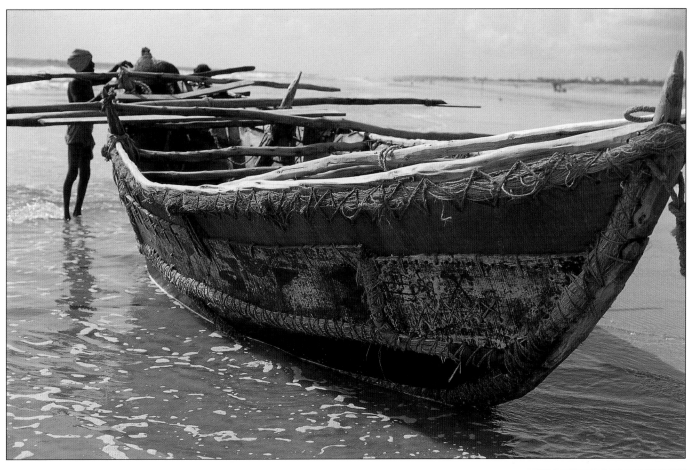

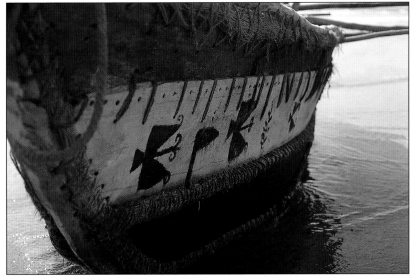

There were many experiences during my travels in India that have contributed to my work and to my identity as a craftswoman.

Bhuj is in the Indian state of Gujarat, and while there I visited the Ana Mahan Museum that later was destroyed in the 1991 earthquake. The museum was originally a palace that was constructed in 1752. Inside, embedded in, hung on the walls and covering the furniture, were thousands of mirrors. The mirrors, resplendent and reflective, displayed wealth, prosperity as well as protection against the evil eye. The same luminescence, found on a more humble scale, is repeated in the bhongas (mud huts) and the mirrored dress of the local people of Gujarat. During the night and especially during festivals, the embedded mirrors in the walls of the bhongas and in the embroidered clothing reflect light so that there is a shimmer everywhere.

Visiting craftspeople in other countries is a powerful experience. Since they usually do not speak English, I always see a thousand questions in their eyes, especially of the women. It saddens me not to speak their language however, we had something in common. They oohed and aahed when they looked at my hands and saw that I had embroidery calluses as they did.

Quiltmaking using mirrors as embellishments is a Gujarati tradition in the Great Rann of Kutch at the Banni villages of Jarar Varvandh and Dhordo. It takes careful observation of hands, body language and materials to determine what is happening when visiting non-English speaking countries. I could have stayed in that village and all the other villages I visited for a long time.

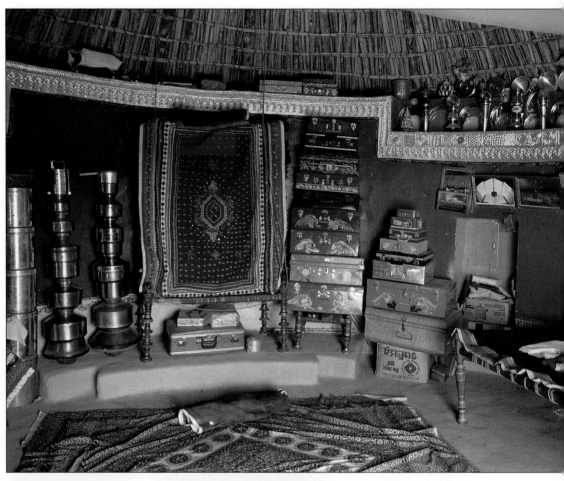

Mithi Bei Ranmal Pathan, embroiderer from Jarar Varvandh

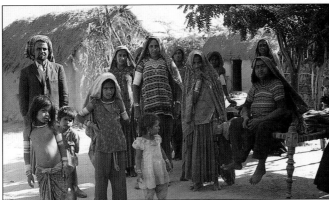

Embroidery detail of the Bhulbhulaiya stitch (labyrinth or forgetful stitch). It is an intricate, interlacing, surface darning stitch. In the West this stitch is known as the Maltese Cross.

Villagers from Jarar Varvandh

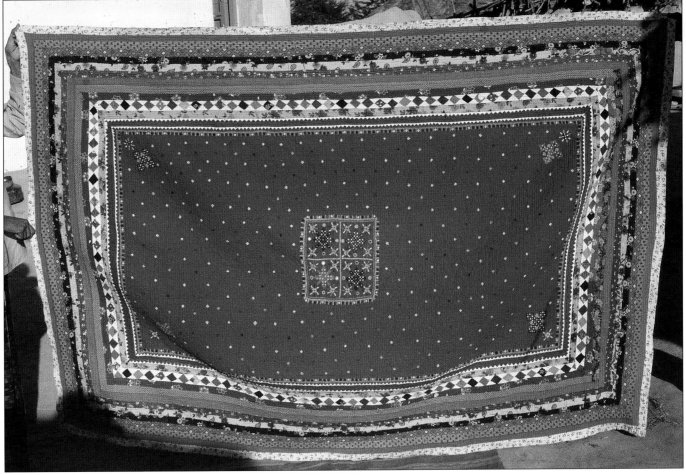

Quilt from the village of Jarar Varvandh, Gujarat, India, 1978. 56 X 85 in., 142 X 216 cm.

In Sri Kalahasti, Andrah Pradesh, I visited J. Gurappa Chetty, a kalamkari painter who showed me the importance of story, details and scale. His natural-dyed, painted cloths depict stories from the Ramayana and Mahabharata.

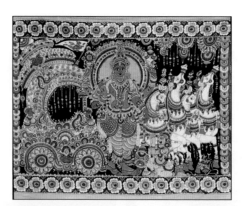

J. Gurappa Chetty, Sri Kalahasti, Andra Pradesh, India, 1980. Krishna at the Battle of Kurukshetra and The Ten Avatars of Vishnu, from The Bhagavad-Gita, 46.5 X 188 in. 116 X 478 cm.

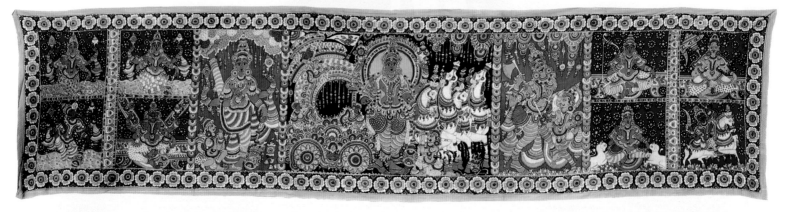

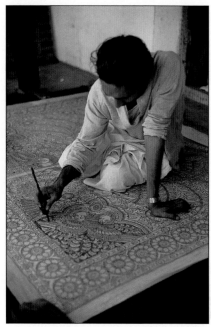

J. Gurappa Chetty painting alum on a kalamkari

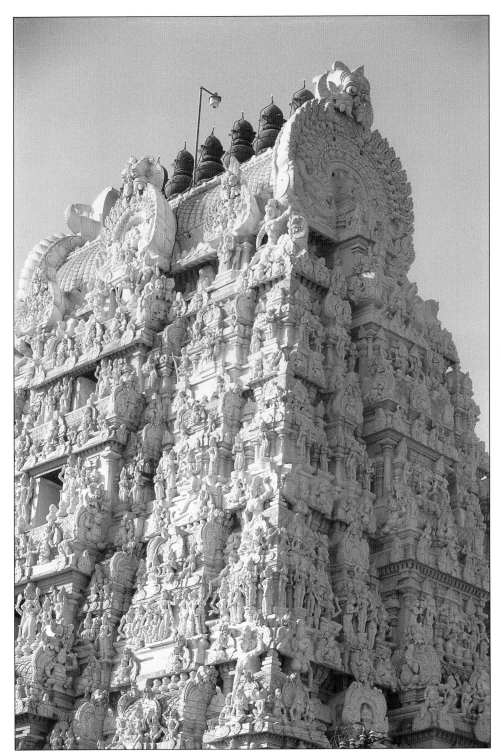

The beautiful carvings on the Hindu temples of India also inspire me. Hindu Gods carved in stone are images that are frozen on the walls. These dynamic, busy exteriors covered with figures filling every space with light and shadow showed me the importance of an active surface.

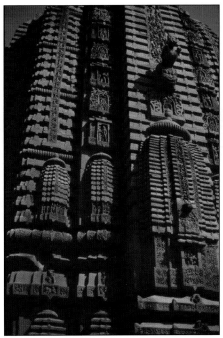

Lingaraj Temple, Bhubaneswar, Orissa, India

The Kamakshi Amman temple, Kanchipuram, South India

I was struck by the contrast between India and Japan. India is seething with wonder, heat, life and color, while Japan has a quiet majesty that exists beneath the hustle and bustle of everyday life. I like the mysterious dark places in Japanese traditional houses, Buddhist temples and Shinto shrines and I enjoy visiting Japanese craftspeople. Japan is a place of textures, shadows, elegance, cuteness, noise, good coffee and quiet places when it all gets to be too much.

Katazome on fabric using rice paste resist. Yamasaki Seiju Studio, Gunma Prefecture, Japan

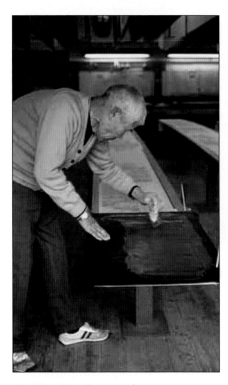

Stenciling fabric (katazome) using chemical resist. Kuriyama Kobo, Ukyo-ku, Kyoto, Japan

Katazome fabric ready to be painted. Yamasaki Seiju Studio, Gunma Prefecture, Japan

Hikizome using kusakizome. Yamasaki Seiju Studio, Gunma Prefecture, Japan

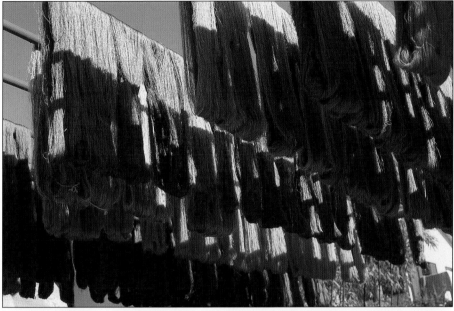

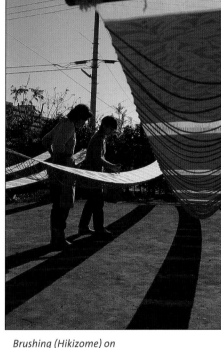

*Kusakizome dyed silk yarn.
Yamasaki Seiju Studio,
Gunma Prefecture, Japan*

*Brushing (Hikizome) on
natural dyes (kusakizome).
Yamasaki Seiju Studio,
Gunma Prefecture, Japan*

*Washing kimono fabric
in the Kamo River, Kyoto,
Japan*

*The wall around Daitokuji,
Kyoto, Japan*

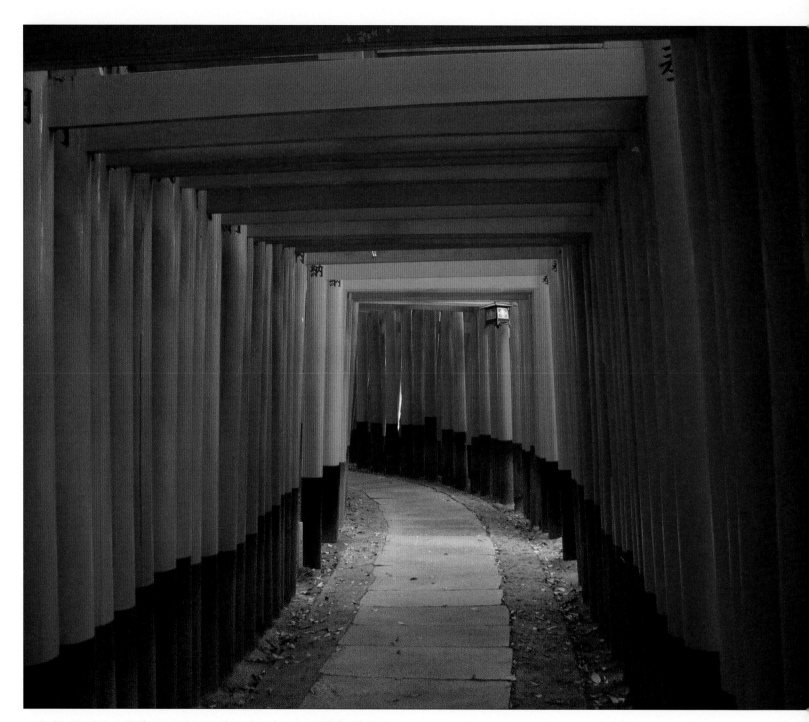

Fushimi Inari, Kyoto Prefecture, a transcendent place that seems filled with spirits

*Shadows on the rocks in
the pond at Heian Jungu,
Kyoto, Japan*

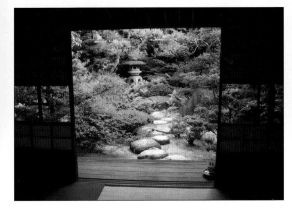

*Quiet place in Arimatsu,
Aichi prefecture, Japan*

*Corridor at the Yeulu
Academy, Changsha, Hunan
province, China*

*Mysterious, lush entrance to a sub-temple at
Daitokuji, Kyoto, Japan*

I am always looking for work that reminds me of my own quilts. In Mexico I saw many different multi-layered sheets of colored tissue paper decorations called papel picado. They are decorations that are usually used for local fiestas.

The use of paper stencils came to Japan from China. Paperwork apparently was among the imports that traveled on the boats that came to Mexico from China. Once the craft arrived in Mexico it became the basis for papel picado. Another common name for the material is papél de China, or Chinese paper. This tells a clue to its origin. Its origin could be closely connected with the invention of paper during the Han dynasty (206 B.C.-221 A.D.). As paper was highly precious in those days, the art of paper cutting first became popular in the royal palaces and houses of nobility as a favorite pastime among court ladies.

Stencil With Court Ladies,
30.25 X 31.5 in, 77 X 80 cm.
Lui Da Pao, Fenghuang,
West Hunan province,
China

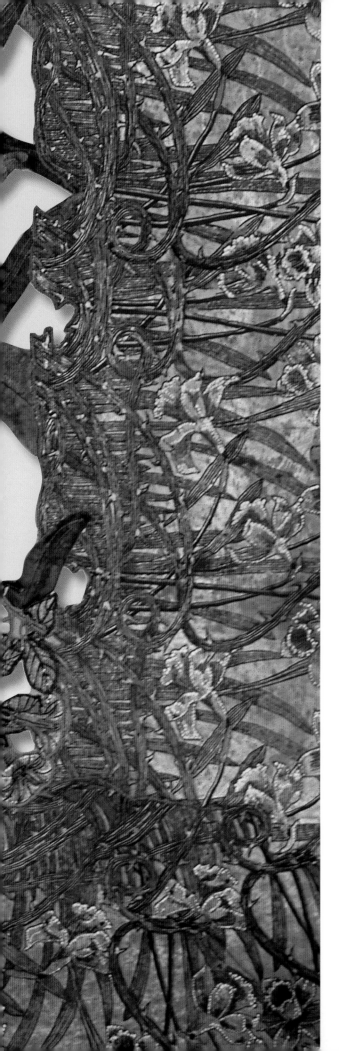

The Trip Down the Rabbit Hole

"Would you tell me, please, which way I ought to go from here?" said Alice

"That depends a good deal on where you want to get to," said the Cat.

"I don't much care where," said Alice.

"Then it doesn't matter which way you go," said the Cat."

—LEWIS CARROLL, *Alice in Wonderland*, 1865

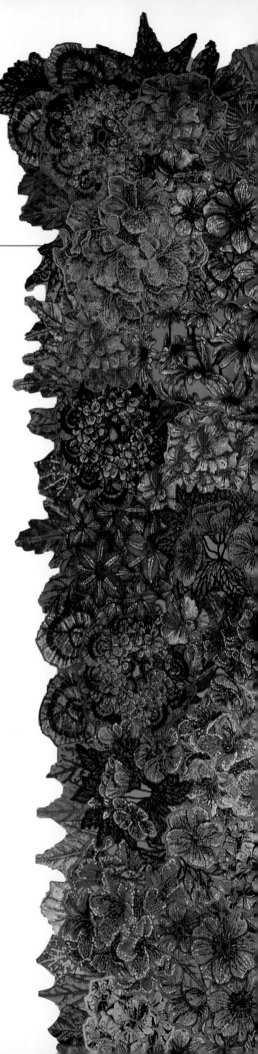

What is the shape or form of an art quilt? What is an art quilt? Is this the correct name to describe a new and evolving art form? Can paintings be described as art paintings or sculpture be described as art sculpture? If the shape is different can it still be called a quilt? Contemporary quilt makers are pushing the envelope. They are making three-dimensional objects, small quilted wall hangings, and quilts of various forms from those quilts that are traditional. They are a form of personal, formal, visual expression.

If work is to be considered an art quilt then the language of art will be the primary means of communication. The ideal is to know the language, techniques, materials, and critical analysis so well that the mental process becomes second nature and the work flows automatically. The failure to express oneself is because of the inability to use the language of art, its processes and materials. A person cannot expect to write novels in Spanish if they do not read, write and practice the language. The language of art is similar. I always recommend going to art school, taking art classes, and going to museums and galleries to see what has been created before.

If you want to have an adventure, the right situation needs to happen that will create magic and mystery. There is mystery and magic everywhere you look. You have to create the right time and place. It is important to take advantage of what the ancient Greeks called kairos. Kairos is "a passing instant when an opening appears which must be driven through with force if success is to be achieved." Kairos is opportunity, the right place, the right time when something should happen.

Each mistake made doesn't narrow the possibilities but expands the choices.

Art is a different culture with its own language. The culture of art is similar to living in a foreign country for a long time. If one doesn't know the language then you have to take a tour. You will see the country superficially through the eyes of the tour guide and what they believe that you should see. On the other hand, a knowledge of the language will ensure a richer and deeper experience. Being able to exist within the culture of art depends on communicating within this culture. To live within this culture depends on practicing the language every day. The creative part of making quilts is what is said and how it is said. It is easy to feel lost and out of place but no one can help until you begin to research, study and speak the language. There is no truth or process to follow the illusive something. It just doesn't exist. Art can't be caught like the measles or come like a gift of divine grace. You can't sit around waiting for your muse. She must be actively pursued. For each person the path will be different. You must get yourself going.

People who lack knowledge of the language of art, who have to be secure at all times, who have to copy the work of others, and who want things to happen quickly, or are used to having others make decisions for them, will have trouble moving about in this culture of art. All the basic underpinnings that support a person in a different culture are unique so one has to accept that and go on from there.

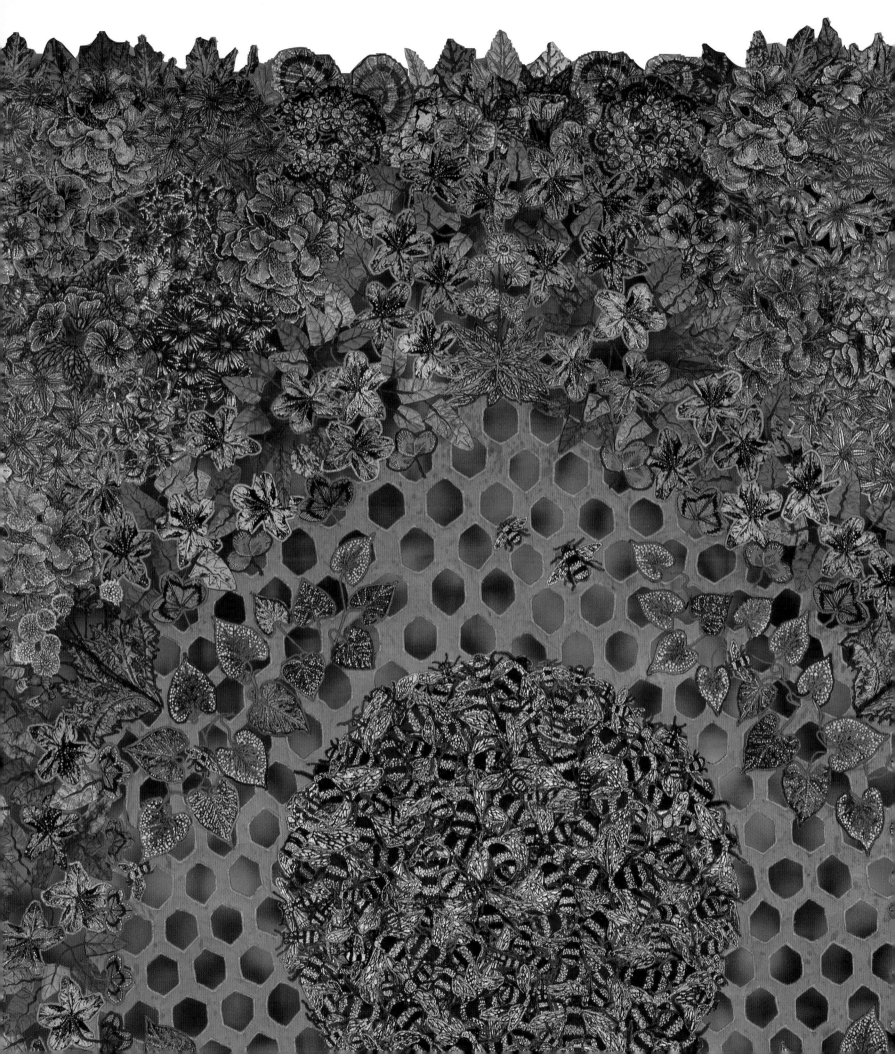

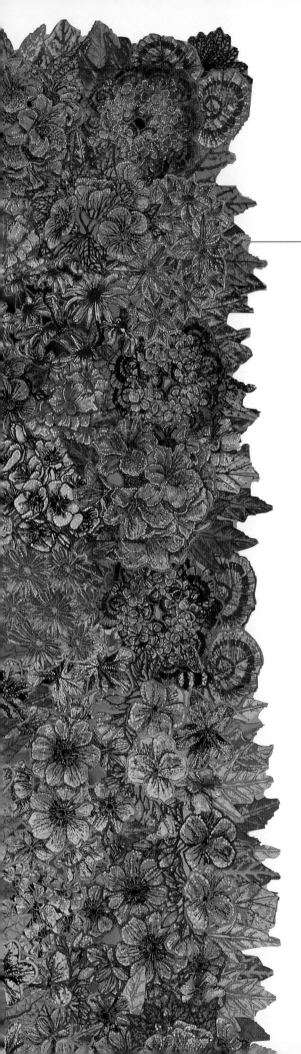

Living in another culture is not easy. While you are learning, the best way to get along is to never make value judgments. If you do you will have a terrible time. If you find yourself overwhelmed, judgmental, or lacking confidence, the only problem is that you are having a case of culture shock. Things might not happen as quickly as you might wish. Get used to relying on yourself by using your perseverance, visual perception, common sense, inventiveness and of course your knowledge of the language of art. Making art is a solo voyage. It is not for the faint-hearted or those who are not used to traveling alone.

There are things to do to make your trip more meaningful; draw every day, try different tools and media, try things that you never tried before, break out of your creative prison. Take a life drawing class, especially if figures are used in your work. There is nothing more disturbing then a poorly executed figure with mittens for hands and feet that look like they are wearing socks. Showing the volume in a figure can be accomplished by the barest of strokes. If you know nothing about the figure, its volumes, nuances and proportions then you shouldn't be using figures.

In the West the figure is the ideal of God-like perfection. Art schools consider figure drawing a basic skill. It is thought if someone can draw the figure than they can draw anything.

In the East the landscape and the ability to show its chi (spirit) is more important than the figure. The reverence for nature in Oriental art is similar to the reverence for the human body in Western art.

Actively participate and pursue knowledge by doing research, reading and going to museums. Don't assume that you know everything, but rather have a humble attitude. Learn a new way of doing something familiar even if it means a basic struggle. Above all create every day. It is your cultural and psychological binds that are tying you down. Prepare to take this journey very seriously.

It is important to make your own way and be your own travel guide. This includes packing a metaphorical suitcase with everything you will need on your travels. This could be a sketchbook or box filled with ideas. It will document where you are at in a particular point of time. Putting items in your sketchbook or box will allow you to have flights of fancy, work out visual problems and clear out your head so you can move on. This metaphorical suitcase could hold a journal, swatches of color, photographs, fabric, techniques and combinations of all these things. It can contain some typical theme, form, design, pattern or motif. Sketch, cut out and/or photograph this design/object/motif. Collect as many variations of this as you can. Try to find out its history. Look for it everywhere, in books, magazines and museums. Make connections between disparate objects. Just remember the five basic rules for finding information: who, what, where, why, and how. Look carefully at what you are seeing. Do not make any judgments about what you see and what is happening around you. Just record it.

These are thoughts that help me on a trip. I study the culture before I take the trip. I study the history, techniques and, sometimes, the language. Although there are surprises, I do this so nothing would seem too strange to

me. I am always conscious of where I am and how I relate to my surroundings to avoid getting into trouble or getting mugged.

Do not try to pull an idea out of the air, because all it will be is a good idea without background or substance. Do not meditate on a particular piece of music or literature. Let the results flow from the process of working and the content will take care of itself. Intention is a powerful force. Do the work first and then explain yourself later after the finished object is in front of you. It is important to capture the invisible spirit behind the thoughts, and not the visual and familiar.

An emerging artist or someone who is serious about their art might not have the language to make their ideas concrete. The language of art must be studied and practiced every day before it can be spoken. Variety should be created in communication to make the language rich, filled with color, tone and metaphor. Work can be a variation of theme or process, a compelling vision, and a consistent style.

In work with process, sketching might not be helpful. This process is an intuitive manner of working. However, when I begin working I am very deliberate. My process is so long and involved that I must sketch beforehand. I always begin with a frame on the page that helps me to establish a reference point. I usually do all my drawings on graph paper that immediately gives me the size, amount and placement of images. I leave the intuitive process for painting.

Working with photographs is sometimes easier for some because the subject is captured, flattened, and framed already. The camera will capture the immediacy of the moment. The camera doesn't know what it is looking at, but in looking at the photograph something the camera saw but wasn't apparent to you at the time will become apparent.

While sketching, photographing or assembling, use your powers of observation to look, see and understand what you perceive. Look at what you are sketching from several points of view, flattened, three-dimensional from the top or side. Include different points of view in the same sketch. Design asymmetrically.

Sharpen your powers of observation by sketching from life. Use blind contour drawing; it helps to reinforce what you see. Put in all the meaningful details that you observe and use various details to construct pattern. Enlarge details for a different point of view since in the details exists the essence of the idea. Work with the negative space and use it to your advantage. Make your design flip from positive to negative. Try repeating elements by mirror imaging, blowing them up or shrinking them. Show depth of feeling by the quality of line or the different elements of the sketch.

When you make visual decisions do them consciously. Native ability will only take one so far. Eventually decisions will have to come from some conscious effort to relate the visual organization to the subject and content. Consider the composition and how the ideas and design are arranged. Formal principals of art and design should be used effectively. Is there a purpose for the composition and does the arrangement strengthen or weaken the work?

Clarity in your concept and design will show that you understand the elements of art and design while using fabric and technique to their best advantage. Taking risks is the most essential part of being creative. Following someone who has taken a risk already makes your work derivative. Try something new and think about different ways to solve the problem. Ideas and drawings have to go through several stages before the best design emerges. Yet, cheapening and overworking an idea until it has lost all its freshness and creativity is not good either. The design should be fresh, new, personal, unique and memorable. The design not made from personal experience or made from direct observation is a meme. Taking a design from direct observation will be uniquely personal. The ride down the rabbit hole can be fun.

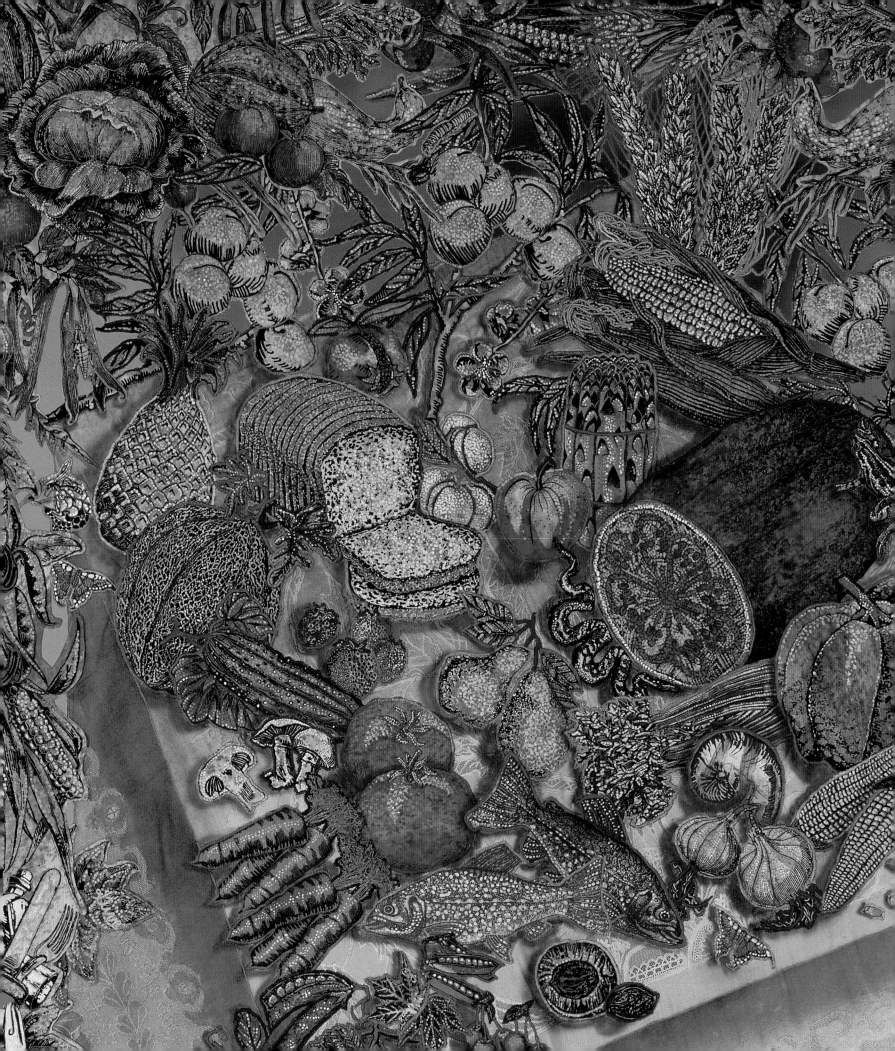

VISUAL CRITIQUE

Said the Duchess
"everything's got
a moral,
if only you can find it."

"What do you mean by that?"
said the caterpillar sternly
"Explain yourself."

—LEWIS CARROLL,
Alice in Wonderland, 1865

ON ICONOGRAPHY AND ICONOLOGY

To be able to be a functioning artist it is necessary to critique your work during the process of working. Here are some definitions, suggestions and techniques that are helpful.

The iconography of a work of art is its imagery or subject matter. The iconology is the content or study of those images, their interpretation, or meaning. An apple as the subject is not an apple, but rather the representation of an apple composed of the elements of art through the artifice of the formal elements of form, line, color, etc. The image itself is an iconographic motif. But from the point of view of iconology, the apple could be a symbol...an apple is the symbol for the fall of Adam, New York City's big apple, as well as a brand of computer.

To learn to have meaningful conversation with the work there are some helpful techniques for using this language and for obtaining a critical distance from the work. This will help to relate the iconography to the iconology, subject to content.

Semiotics is the study of signs. Semiotics involves not only street signs, body language, smiles, frowns, flashing lights, sounds, and store signs but also refers to the use of language to describe art, to analyze and interpret the icons or subject of a given work. Signs can be in drawings, sculpture, ceramics, painting or quilts. The work is the stage where everything is revealed. The stage is the picture plane. In practice the picture plane is the same as the actual physical surface of the object, be it a painting or a quilt. Within this plane there exists shapes, forms and colors that are

invested with meaning and give the viewer insights into how images can be effective.

Linear perspective, the technique used to create the illusion of space in a painting or drawing, has served as the golden rule for artists since the Italians developed it during the Renaissance. Within the picture plane Hans Hofmann, the 20th century painter, developed a technique he called "push and pull," that accomplished the same illusion of space within the work of art without using perspective. Hofmann proved that the illusion of space, depth, and even movement on a canvas could be created abstractly using color and shape, rather than representational forms. "Push and pull" can also be used with images if the images are viewed in a formalist manner. Within this plane semiotics can be used for the description, analysis and interpretation of icons or iconic representations.

Semiotics clarifies and makes sense of the visual. The use of semiotics can help the artist to interpret the meaning behind the work by describing the visual, since most people can only see what is part of their reality. Describing the work with words will sharpen and clarify what is seen. It has been thought that the artwork stops with the recognizable image since realistic images are easier to interpret. Reality can have a symbolic element also. Work that is purely abstract may be more open to subjective interpretation. Art is not a Rorschach test, but rather an example of what philosophers call reification, the process of regarding an abstraction as a thing. It is better to train oneself to look at art for the pleasure of the abstraction.

The elements of art can lead the viewer into the artwork but they also create the atmosphere. The basic step in viewing is to describe what is seen in the artwork. You must talk about what exists in the work, not what you think is there, or what you think others should see.

Even if the work is abstract, proportion can create space, marks make texture, colors convey feelings, shadings express moods and create atmosphere, lines create emotion and movement, elements contract and expand, and shapes overlap. Many other characteristics within the layout can help the eye travel over the work bringing the separate elements together into a complete composition. The manner in which these elements are used enhances the subject and invests the work with meaning and perceptions. All work can be enhanced by infinite visual nuances that can transcend words. It enables magic to happen in the mind's eye.

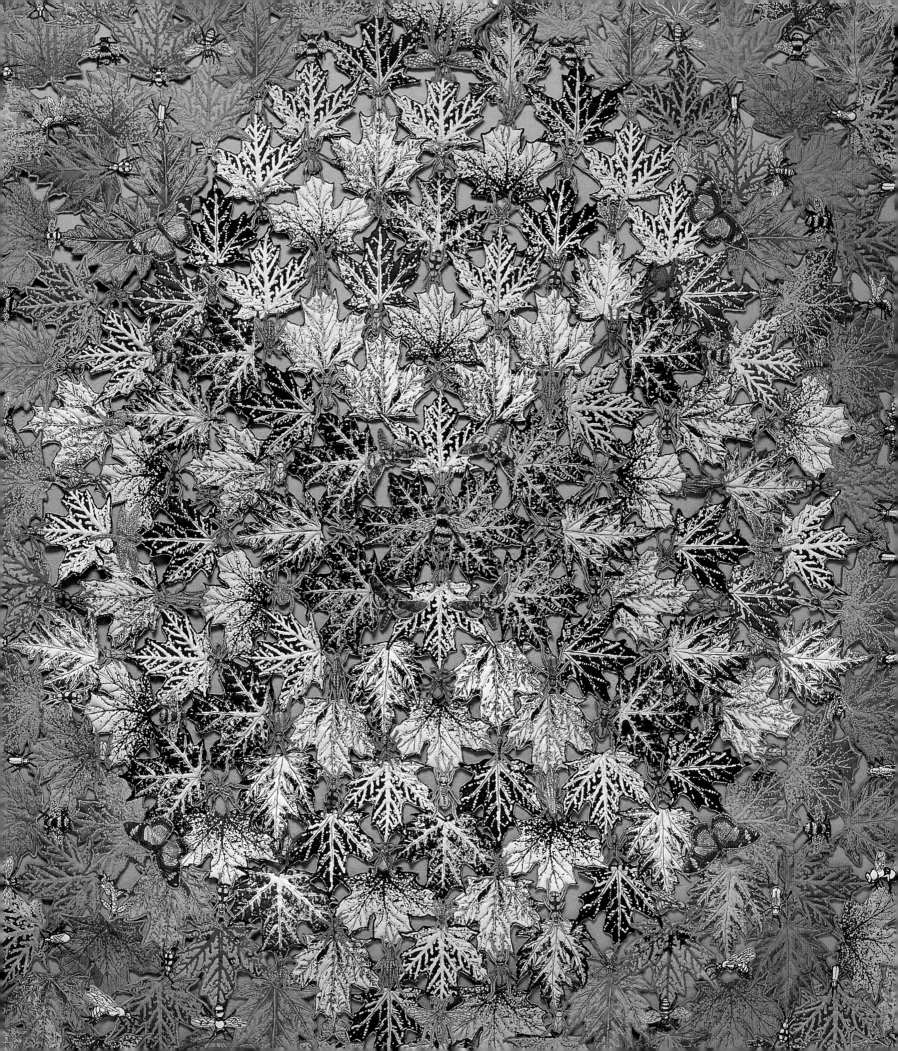

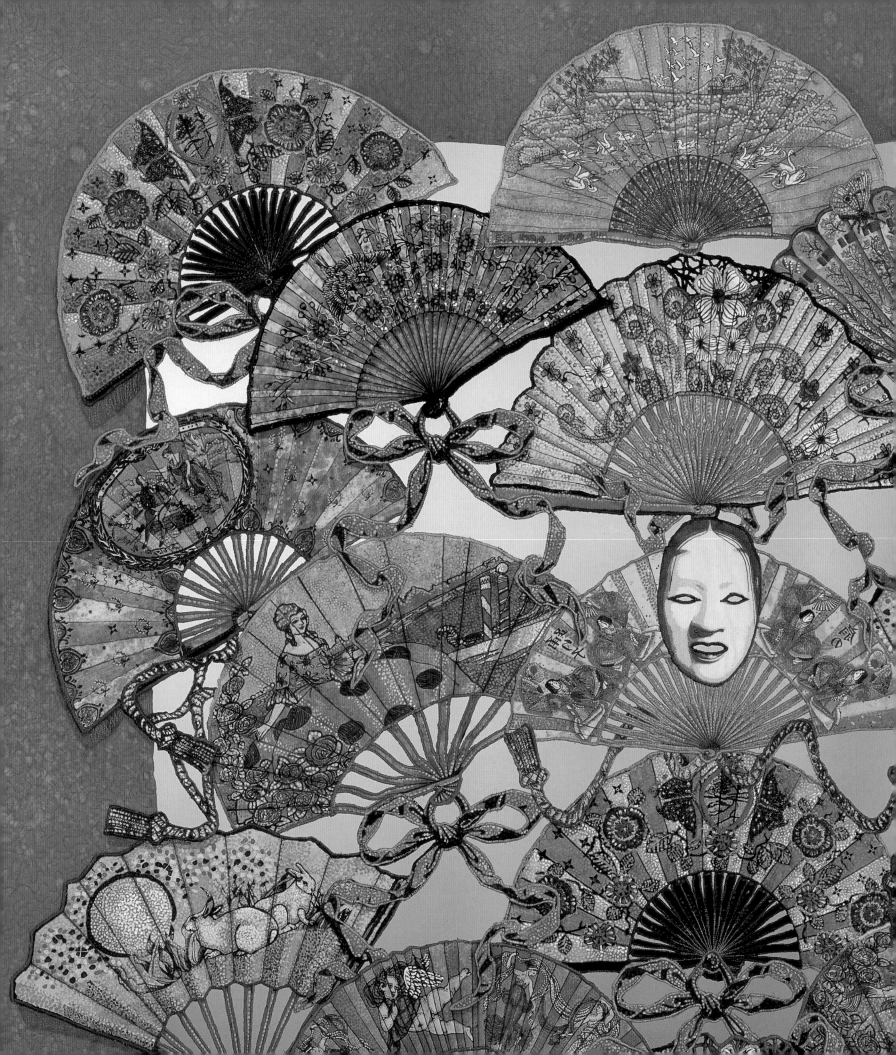

USING SEMIOTICS FOR CRITICISM

Takashi Murakami is an artist, curator, designer and writer. "Westerners don't care about those vague, 'oh-what-a-beautiful-color' kind of impressions, as Japanese do," he writes. They "enjoy intellectual 'devices' and 'games' in art. That is why one must contextual-ize work in the world's art history."

Using semiotics for criticism is a three-step interactive process that will allow for a deep dialog with the work. The three steps are reduction, contemplation and interpreta-tion. This manner of criticism can be used not only for the work of others but also for self-criticism. It allows for the removal of the sentimental and the irrelevant from the work. It is a non-threatening manner of criticism where there are no positive or negative comments implied. Artists want to hear that their work has some importance and meaning. It is a dialog that will get rid of snap judgments and com-ments, such as "I like it." That is not a good statement to use with a careful analysis of a work of art. It stops all discourse because what can be said after that?

Working with semiotics or signs in the work helps to lay down an intellectual founda-tion that strips the work down to its basic principles and relevant visual elements. It sharpens your reality to access what you see. It will allow you to see work from new angles and points of view. It will give you positive choices in the direction you might go and to accept the possibilities.

Reduction is the first step of the process. The semiotic (sign) needs to be reduced to its important visual elements. This is done by subtracting them, describing them, and by simplifying the work into its separate, relevant parts. Reduction enables postpon-ing one's various beliefs in order to study the essential structures of the work. This description will allow intimacy with the work by focusing on all the visual parts. This allows the progression to the next step, the actual meaning of the work itself and the el-ements that are responded to. Do not cheat

yourself by drawing upon conventional, pre-existing signs and codes. This would make you the instrument of the signs rather than the master of the codes. For example, many people like to add embellishments to their work, forgetting that adding a feather, metal pieces or a CD will just be a feather, metal pieces or CD unless they fit visually within the composition as shapes and colors.

The second part is contemplation and is based directly on what can be visually interpreted or sensed in the work. Culture and experience dictates what impressions are permitted. This will help in discovering what kind of importance is contained in the structure, shapes and colors of the work.

The third step is interpretation and the sense made of the signs and elements. Realistic images serving such communica-tive purposes may be more easily opened to interpretation than abstract ones. Contem-plation helps to inquire and discover what kinds of meanings could be contained in the configurations, shapes and colors themselves and interpret the nature or meaning of that experience. The positive dialogue with the work will suggest in what manner it can be improved. Any visual arrangement has a potentially infinite number of qualities; we need to know which of these are most likely to be relevant to our needs and experience. Because of a new intimacy with the work, not until interpretation is completed should any expression of like or dislike be expressed.

There is an ancient artist's saying, "If you do not know your materials, all you do is express your inability to express yourself."

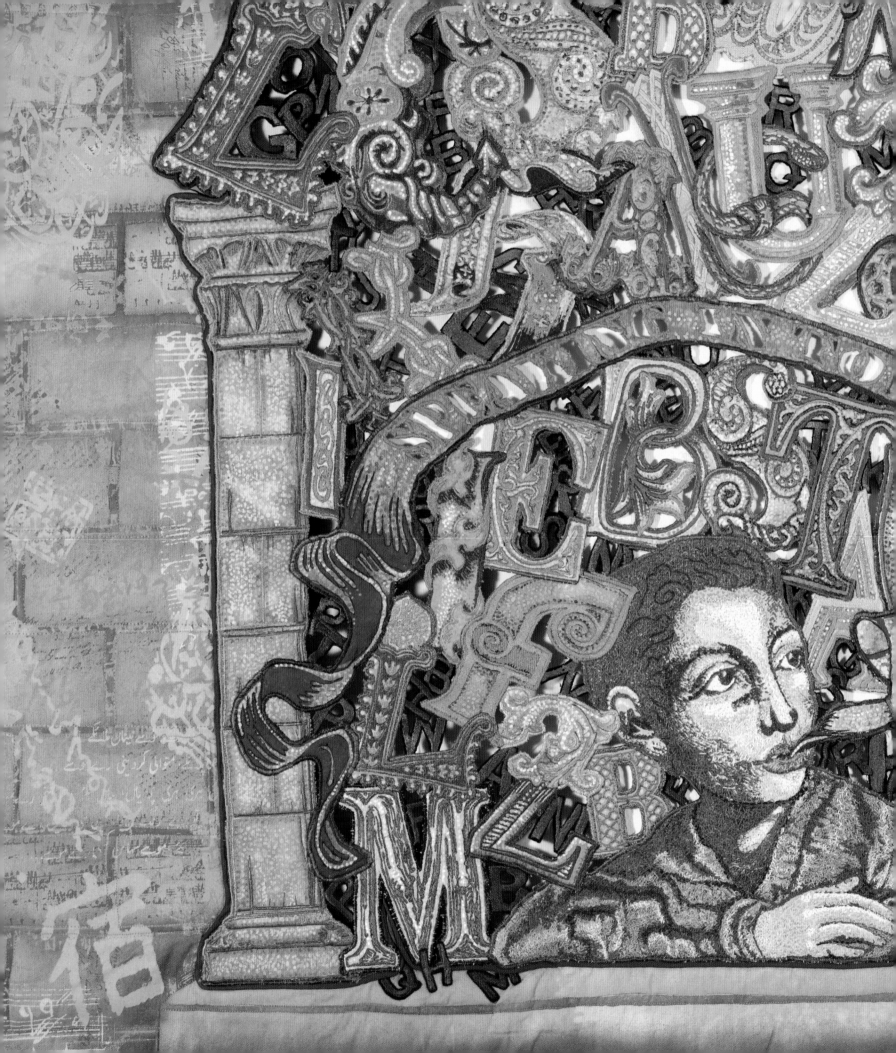

THE WIZARD BEHIND
THE CURTAIN

"Of course it must,"

Humpty Dumpty said

with a short laugh;

"my name means

the shape I am—

and a good handsome

shape it is, too.

With a name like

yours, you might be

any shape, almost."

—LEWIS CARROLL,
Alice in Wonderland, 1865

n this chapter I want to talk about what I consider important in my work.

I had to change the media and the direction of my work four times in forty-five years. Due to life, finances and the discontinuation of materials, I came to the conclusion that I would never be a slave to supplies. In 1984 I began the work that would define the themes and subjects for the rest of my life. In Japan I went to study *kusakizome* dyeing. The word *kusakizome* means grass and tree dyes or natural dyes. While studying natural dyes in Japan, I also took classes in *katazome*, a stencil printing technique that uses paper stencils to apply a resist of rice paste before dyeing. Initially it was a technique that I could use to test my dyes. I never thought that it would affect me so profoundly. I became fascinated with carving the stencils and staring at the negative spaces.

Detail of my carved stencil, 1995

It was tedious, meditative work. I began looking at my quilts and wall hangings in a new way. I wanted to lighten them up to allow them to breathe and hang in space in the same way stencils are made with bridges and connecting elements. I would also design my work to make the connections as part of the design. In addition I was able to include in my quilts all the things that I loved since I was a girl; coloring inside the lines, cutting and pasting, collecting, lace, quilts, art, design and stories.

I am always asked what would happen if I would ever run out of ideas. I probably would if my work was based on ideas. Since my work is based on previous work, conscious choices and directions, these are the seeds for subsequent work.

I use permutations of the same image, many variations of similar themes, and variations of one motif. A single image provides me with the opportunity to develop other images. These images are like old friends with different personalities. I like to steal reality and manipulate it. Art is happening everywhere, every day.

I like a random imperfection that calls up a memory of things past, draws my attention, and becomes part of the creative process. Because I am stimulated, I return again and again each time seeing something new, and a fresh, different aspect. I constantly look at old quilt patterns and quilts for inspiration, not only for the names of the patterns but also for how the positive and negative relate, create repetition and seriality. These are the whisperings of the past.

Book of old quilt pattern clippings dated 1909-1940. Included are many Florence LaGanke Harris' quilt columns called the Nancy Page Club. The quilt patterns were pasted into a catalog of The Western Druggist's Prices Volume 2, 1881-1882.

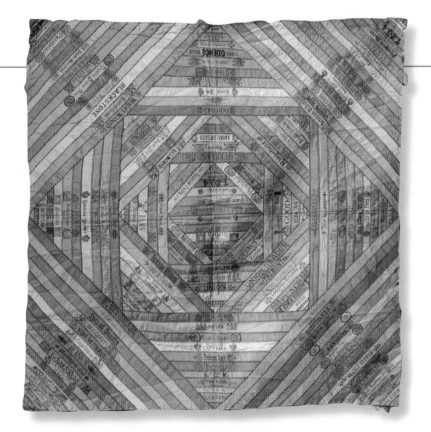

Unknown quilter, cigar ribbon pillow cover, 1904, 34 x 34 in., 86 x 86 cm. Collection of the author, given to me by my father.

In the late 19th and early 20th centuries cigars were not sold in boxes but in bundles of twenty-five or fifty cigars. These ribbons were saved and used in handicrafts. The ribbons were usually in shades of gold and yellow, less frequently red or white, and bore the brand name of the cigar or various other labels, such as vaudeville actors and other popular celebrities. The ribbons are sewn onto muslin and fastened with herringbone stitches.

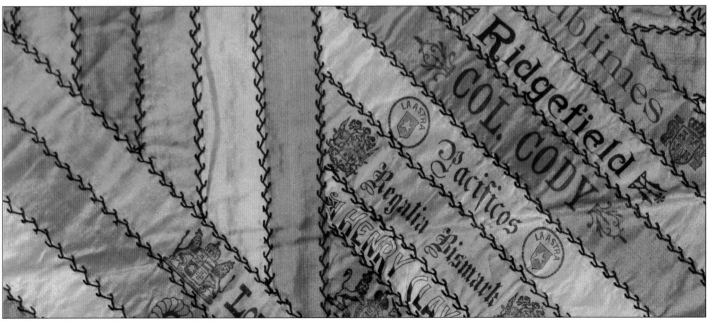

Unknown quilter, 50.5 X 64.5 in., 128 X 164 cm. Collection of the author

This quilt with its shimmering surface of darks and lights is made on a muslin foundation similar to a crazy quilt. The pieces are embroidered with herringbone stitches. The border is a wide silk ribbon. The back of the quilt is tied with ribbons.

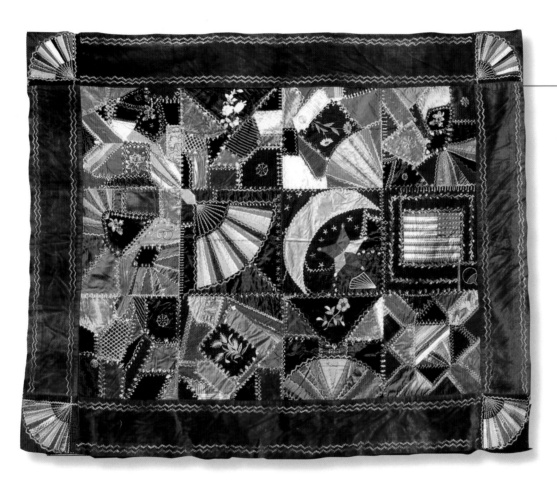

Crazy quilt, unknown quilter,
59.5 X 76 in., 175 X 193 cm.
Collection of the author

This quilt was made in a lumber camp in Montana. It is made with silk, velvet and three commemorative ribbons. The ribbons are from the Helena Board of Trade, 1886 and 1888, and the Coronat Opus, Banquet of the Citizens of Helena to the Manitoba R'y and the Montana Central R'y given at the Merchants Hotel, November 21st, 1887. The quilt is embroidered with variegated silk thread and with many different embroidery stitches.

The American flag has forty-two stars. This was an unofficial forty-two star American flag. Because a new flag design does not become official until July 4th, there should not have been a forty-two star flag. Washington was admitted as the forty-second state on November 11, 1889. The forty-two star flag would have become official the following July 4th, but Idaho became the forty-third state on July 3rd, so the new official flag would have forty-three stars.

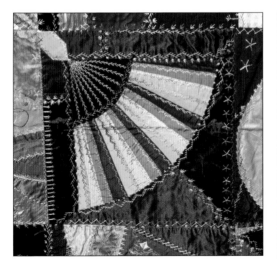

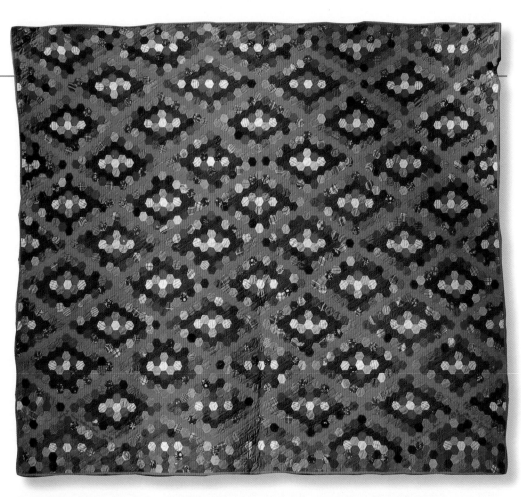

Work of Grandmother Snell, age 88. 1892, Dallas Center, IA. Mrs. L. A. Everett. 66 x 74 in., 168 x 188 cm. Collection of the author

The quilt is made of orange wool, various heavy cottons and flannel. It has a cotton batting and a linen backing.

The Legend of Tristan Quilt, detail,
ca.1400, Sicily, Italy. 122 x 106 in.,
259 X 269 cm. V&A Images/Victoria
and Albert Museum

This quilt is one of three Tristan quilts
still in existence. The legend of Tristan
and Isolde was a favored narrative in the
Middle Ages and appeared in many forms
in literature and in the decorative arts. The
story represented here on a quilted linen
coverlet, in fourteen scenes, is that of the
oppression of Cornwall by King Languis of
Ireland and his champion the Morold, and
the battle of Sir Tristan with the latter on
behalf of his uncle King Mark. Although in
subtle shades, the large scale designs are
very clear and the quilt must have looked
particularly impressive by candlelight, with
lively scenes of battles, ships and castles.

This quilt is my favorite of all the historic
quilts. I was quite fortunate to see it in per-
son in 1974. The quilt is made of two layers
of linen with the main elements sewn in a
backstitch with brown linen thread. The tra-
punto technique was used to raise some of
the quilted patterns. The other unimportant
patterns are sewn with natural linen thread.

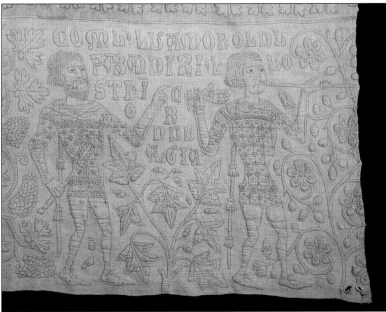

On Process

I use any technique that I want, and which technique I use depends on what I want to achieve visually. As artists we can do anything and go anywhere with any format.

I never use commercially patterned fabric. I cannot depend on the fabric industry to supply me with images that I need since I marry the fabric to the form and content. I cannot create according to what is popular and in fashion.

To achieve my goals there are several visual aspects that are important to me. I am concerned with the elements of art, i.e., form, line, shape, color, texture both implied and actual, space and value. I use the principles of art, i.e., emphasis, balance, harmony, variety, movement, rhythm, proportion and unity.

I like to think about opposites that create tension—light/dark, up/down, negative/positive, contract/expand, small/large, rough/smooth, real/abstract, heavy/light, freedom/order, opaque/transparency, etc. The use of the concepts of opposites creates many avenues of exploration.

Using layers helps me to achieve movement and depth in my work. I dye the fabric by layering color. The second layer is the screen-printed image. The third layer is the painted image. The way I paint the image creates implied texture, light, depth and shadow. I have a vocabulary of marks that I use to paint the images. The fourth layer is the manner in which I quilt the individual pieces that creates actual texture. The fifth layer is the way I fasten the pieces together that creates negative space. The sixth layer is the way I enhance the individual pieces

with shadow, and perhaps I would put in a seventh layer, the embroidery with my sewing machine. This layering helps me to establish foreground, middle ground and background within the individual elements that compromise the work.

Color by dyeing and painting fabric is very important to me. In my studio I have lots of natural, off-white fabric that I dye for each quilt. I like giving up control of a part of my work to the dye pot and receiving in return the random flashes of color that are similar to fire marks on a piece of pottery. I never use black fabric, it seems too resolved, and I hardly ever use pure white fabric.

"Black is like the silence of the body after death, the close of life."

—Wassily Kandinsky, 1911

I use Sabracron/Cibacron F fiber reactive dyes. I have been using them since 1981. The most important features of this dye are that I can use the same dye for immersion dyeing or direct printing. I use eight to eleven colors. With these colors I can mix any color I want. I use a warm yellow, an acid yellow, a warm red and an acid red, a warm blue and an acid blue, fuchsia, turquoise, and black. I use the black to sadden colors or to gray them. Sometimes I will buy a purple. All the colors strike and exhaust at the same time. A stock solution will last longer in the refrigerator. This dye has the ability to migrate into the fibers so I can get beautiful colors with less dye. The process is very forgiving; using them is similar to making spaghetti sauce. I would rather dye my own fabric than ride

around in the car looking for just the right color. While the fabric is being dyed I can do a lot of other tasks.

Phillip Ball writes in his book *Bright Earth: Art and the Invention of Color*, "To the chemist, color is a bountiful clue to composition and, if measured carefully enough, can reveal delicate truths about molecular structure."

I always mix my dyes and paint by looking at reality. I look for the colors that do not appear to be there. To show the fleeting effects of light, I use a lot of yellow because of its importance to the colors around it. I have been inspired by the use of yellow in Van Gogh's work. He was fascinated with color and its effects, and often experimented with different ranges of tone. His use of chrome yellow for his paintings was responsible for the dazzling colors of his sunflowers. It intensifies all the other colors. I paint my fabric with the pointillist technique of clusters of little dots of color that are optically mixed. Using the expansion and contraction of these colored dots makes sense of what something looks like. With this technique I can show roundness and expansion, and shadows progressing into light. I can achieve subtle ranges of tone as well as being able to make the colors appear brighter.

Shape and form are important elements of art in my quilts. They outline and describe the different parts of the quilt and also define the negative space. I look for shapes that can be presences in space. Within this enclosed shape I use the elements and principles of art to bring the shape to life.

My thoughts on negative and positive space comes from the *Tao Te Ching (The*

Book of the Way), written by Lao Tzu about 600B.C. This quote has been influential to the way I see both positive and negative space in art since I was in college.

> *We put thirty spokes together and call it a wheel:*
>
> *But it is on*
> ** THE SPACE where there*
> *is nothing that the usefulness of the wheel depends*
>
> *We turn clay to make a vessel,*
> *But it is on the space where there is nothing that the usefulness of the vessel depends.*
>
> **WE PIERCE doors and windows to make a house,*
> *And it is on*
> ** THIS SPACE where there is nothing that the usefulness of the house depends.*
>
> *Therefore just as we take advantage of what is, we should recognize the usefulness of what is not.*

—Lao Tzu,
c. 600 B.C.

My Work in Process

Step 1: Embroidering the letters

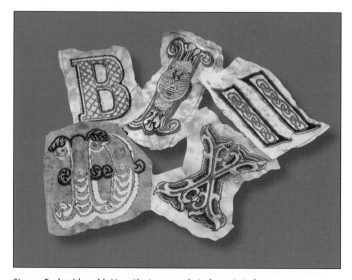

Step 2: Embroidered letters that are ready to be painted

Step 3. Painted letter

Step 4: The embroidered and painted letters ready to be quilted

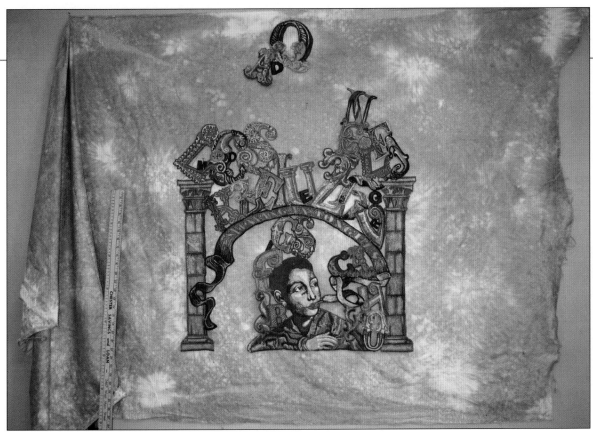

Step 5: The primary pinning on the design wall and border fabric

Step 6: Detail of the letters

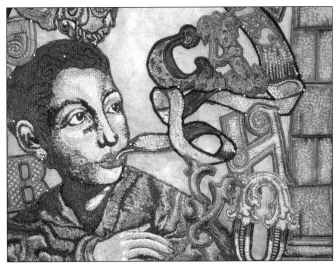

Step 7: Detail of the face and letters pinned together

Step 8: Masking the border fabric in preparation for applying ink.

Step 9: Rolling on the ink

Step 10: The border with most of the masking removed.

Step 11: Masking the border for airbrushing.

Step 12: Airbrushed first of three colors

Step 13: Detail of airbrushed border.

Step 14: Airbrushed bricks for the border of the quilt

Step 16: Transparencies with the screenprinted border

Step 15: Placing the interior of the quilt on the border

BIOGRAPHY

PHOTOGRAPHER: KRISTEN SWENSON LINTAULT

M. Joan Lintault is an internationally renowned quilter who is one of among a handful of the original art quilters. She has been involved in the Fibers movement and has been exhibiting her work since 1965. In his book "The Art Quilt", Robert Shaw called her "...one of the most consistent and original of all contemporary quilt makers."

The work of Ms. Lintault has been exhibited at such places as The Renwick Gallery of the Smithsonian Institution, The American Crafts Museum, The American Museum of Quilts and Textiles, and the Museum of American Crafts. She has shown her work in over 300 exhibitions.

Her work can be found in such collections as The American Crafts Museum; Hoffman Estates Public Library, Schaumberg,

IL; Illinois State Museum,Springfield, IL; Evansville Courier, Evansville, IN; Northern Illinois University, DeKalb, IL; Pere Marquette State Park, State of Illinois, Grafton, IL; Ardis and Robert James Quilt Collection, International Quilt Study Center, University of Nebraska, Lincoln, NE and numerous public and private collections.

Born in New York City, Ms. Lintault graduated from The State University of New York at New Paltz in 1960, with a BS degree in Art Education. She has also earned a Master of Fine Arts degree in Ceramics from Southern Illinois University 1962.

From 1963-1965, Ms. Lintault worked in the Peace Corps in Quinua and Ayacucho, Peru in crafts development where she assisted weavers, knitters and dyers to improve quality of their work, introduced fast dyes, and set up a crafts cooperative. Subsequently, she taught weaving at the Esquela Artisano de Ayacucho where she designed a four-harness loom, a tapestry loom and built spinning wheels.

In 1978 Ms. Lintault received an Indo-American Fellowship Research Grant for nine months study in India. The project was titled "Textile Co-operatives and Processes of India." She traveled extensively in India in order to observe traditional textile processes. She was also able to observe the function and operation of textile co-operatives and their effects on the craftspeople in the village life of India.

In 1984-85 Ms. Lintault received a Fulbright Research Grant for nine months study in Kyoto, Japan. The grant was titled "The Japanese Art of Kusaki-zome (grass and tree dyes)". The Fulbright research included the

historical background of traditional Japanese dyes and their use with the textile resist techniques of katazome, yuzen and shibori.

She has taught and lectured on various surface design techniques throughout the USA, Japan, India, China and Malaysia.

After teaching textile design at the University level for 27 years, Ms. Lintault is currently living and working in New York State.

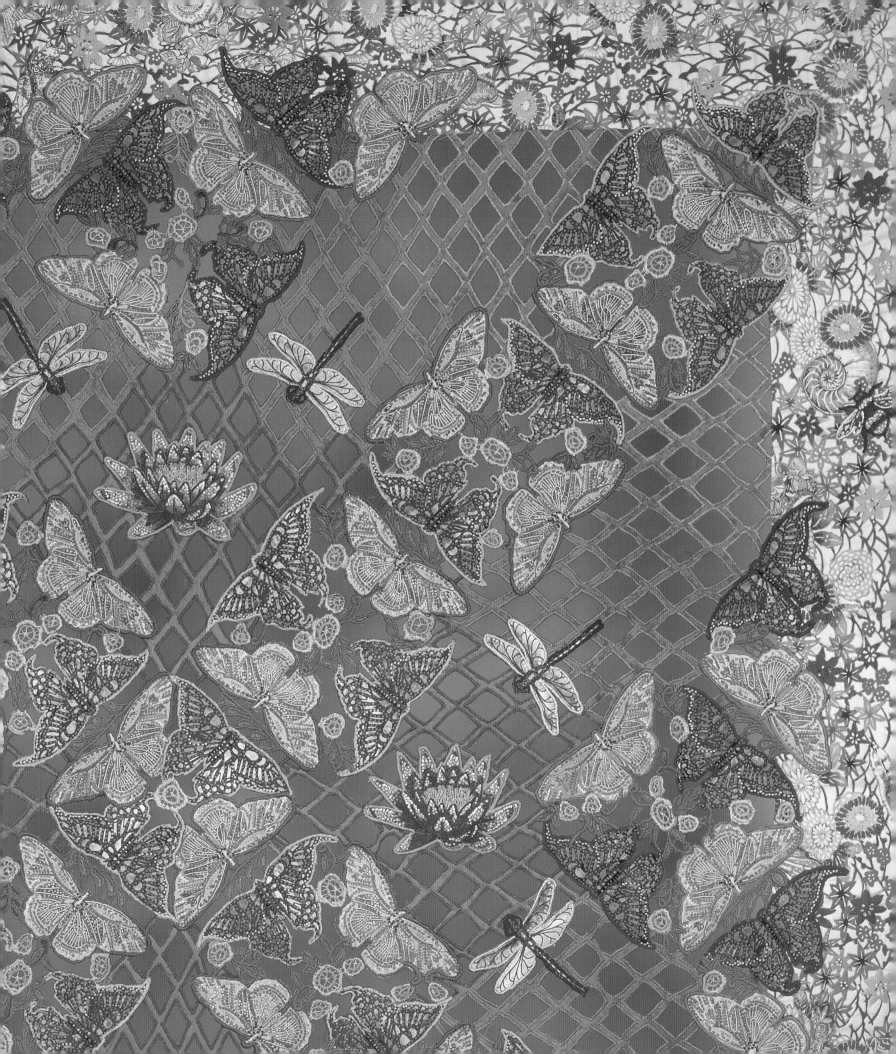

Resources

Sewing Machines

Bernina Sewing Machines

Bernina 740-11
Semi-industrial sewing machine on a power table

Bernina Record 930

Bernina Artista 180
Computerized sewing machine

Bernina Sewing Machines
3702 Prairie Lake Ct
Aurora, IL 60604
800.877.0477
www.berninausa.com

Computer Equipment

Sony Vaio laptop

for use with my Bernina Artista
www.sony.com/index.php

Seagate 160 and 720 external hard drives

www.seagate.com

Apple iMac
2 Ghz Intel Core Duo/2 GB RAM

This computer is used to design my screen print images and print them onto transparencies for screen printing and to store my images for publicity and exhibitions. I also design the images used for my Bernina Artista and to print on fabric.
www.apple.com/imac

Epson Stylus Photo R1800 Printer

www.epson.com

Hewlett Packard ScanJet 5370C Scanner

www.hp.com

Wacom Technology
Wireless Drawing Tablet

www.wacom.com

Software

Adobe Photoshop CS

is used to design all my work
www.adobe.com/products/photoshop

Adobe Dreamweaver

is used to design my website
www.adobe.com/products/dreamweaver

Bernina Customizer/Designer Software

used to digitize my embroidery

Bernina Sewing Machines
3702 Prairie Lake Ct
Aurora, IL 60604
800.877.0477
www.berninausa.com

Hardware

Canon G5 Digital Camera

www.usa.canon.com

Rowenta Iron

196 Boston Ave.
Medford, MA
781.396.0600

Gingher Scissors

www.gingher.com

Organ Sewing machine needles

www.organneedles.com

Screen printing frames

Victory Factory Inc.

184-10 Jamaica Ave.
Hollis, NY 11423
800.255.5335
718.454.2255
www.victoryfactory.com

Pigments and base for
screen printing, airbrush and painting

Vivitone Inc

28 Piercy Street
Paterson, NJ 07522-1726
973.595.1202

Dyes, Assistants and Supplies

PRO Chemical & Dye

P.O. Box 14
Somerset MA 02726
By Phone : Orders Only 1-800-228-9393
Customer Service/Technical Calls (508) 676-3838
www.prochemical.com

Dharma Trading Co.

P.O. Box 150916
San Rafael, CA, 94915
Store address: 1604 Fourth St. San Rafael, CA 94901
800.542.5227
415.456.7657
www.dharmatrading.com

Superior Threads

PO Box 1672
St. George, UT 84771
800.499.1777
435.652.1867
435.628.6385
www.superiorthreads.com

Isacord Threads

www.isacordthread.com

Sulky of America
PO Box 494129
Port Charlotte, FL 33949-4129
800.874.4115
www.sulky.com

YLI Corporation
1439 Dave Lyle Blvd.
Rock Hill, SC 29730
Phone: 803.985.3100
www.ylicorp.com

Hobbs Bonded Fibers
200 South Commerce Dr.
Waco, Texas 76711
800-433-3357
254.741.0040
www.hobbsbondedfibers.com

PUBLISHER

Dragon Threads
490 Tucker Drive
Worthington, OH 43085
Tel 614 841-9388
Fax 614 841-9389
www.dragonthreads.com

PHOTOGRAPHY

Bob Barrett
The Photographer for Fine Craft and Art
photobobb@yahoo.com
(845) 430-8599
www.bobbarrettphoto.com

MY WEBSITES

www.mjlintault.com
A website devoted to my work. It includes a
biography, statement, resume, articles and
news.

indigodye.blogspot.com
A blog devoted to indigo dyeing, natural dyes,
and resist techniques.

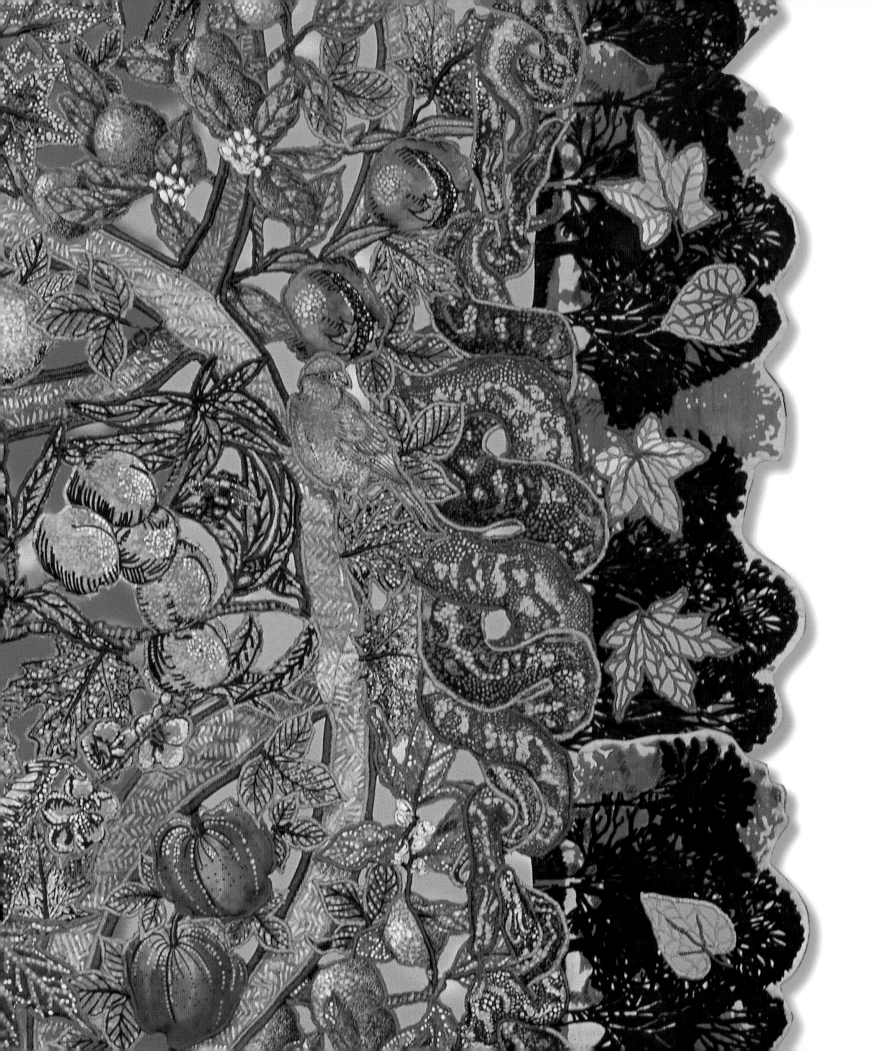

BOOKS

Banners and Hangings
La Liberte, Norman, and McIlhaney, Sterling, New York: Reinhold Book Corporation, an Art Horizons Book, 1966.

Stitchery Art and Craft
Krevitsky, Nik, New York: Van Nostrand Reinhold, 1966.

Encyclopedia of Needlework
De Dillmont, Therese, DMC Publication.

The Textile Arts
Birrell, Verla, New York: Harper Bros, 1959.

One Hundred and One Patchwork Patterns
McKim, Ruby Short, Independence, MO: McKim Studios, 1931.

Mary Thomas' Embroidery Book
Thomas, Mary, New York: Gramercy Publishing Company, 1936.

Singer Instructions for Art Embroidery and Lace Work
Singer Sewing Machine Company, Seventh Edition, Facsimile Edition reprinted by Robbie Fanning.

The Thames and Hudson manual of Dyes and Fabrics
Storey, Joyce, London: Thames and Hudson, 1978.

An Introduction to Textile Printing
Clarke, W., London: Butterworth and Co, 1971.

The Art of Dyeing in the History of Mankind
Brunello, Franco, Vicenza: Neri Pozza Editore, 1973.

The All New Universal Traveler
Koberg, Don and Bagnall, Jim, Los Altos, CA: William Kaufmann, 1980.

Tie Dye As A Present Day Craft
Maile, Ann, London: Mills and Boon Ltd, 1963.

Patchwork
Colby, Averil, Newton Centre, MA: Charles T. Bratford Company. 1958-1971.

Quilting
Colby, Averil, New York: Charles Scribner and Sons, 1971.

The Nature and Art of Workmanship
Pye, David, Cambridge, England: Cambridge University Press, 1968.

PERIODICALS

CIBA REVIEW
Published by the Swiss dye firm Ciba-Geigy from 1937 to 1974. Authoritative articles about the entire textile industry across the globe and across the ages from prehistoric times. Its articles on apparel and the history of costume and fashion of the second and third quarters of the nineteenth century still provide prime source material.

CIBA REVIEWS #68
Dyeing Among Primitive Peoples

CIBA REVIEWS 1967: #1-4 1966-67/8
Japanese Resist-Dyeing Techniques

CIBA REVIEW #18
(Wescher) Great Masters of Dyeing in 18th Century France, 1939.

CIBA REVIEW #31
(Juvet-Michel) Textile Printing in 18th Century France, 1940.

CIBA REVIEW #63
(Buhler) Basic Textile Techniques, 1948. Handicrafts of Primitive Peoples

CIBA REVIEW 1964/2
(Peters) Dyeing Theory, 1964. Early to Latest Research.

EXHIBITIONS
INVITATIONAL

2007 *One-Person Exhibition*
Evansville Museum of Arts and Sciences, Evansville, IN

2005-08 *Quilt National*
The Dairy Barn, Athens, OH
Also included in Traveling Exhibition "B"

2007 *M. Joan Lintault: A True Original*
Special Exhibits 2007, Vermont Quilt Festival,
Champlain Valley Exposition, Essex Junction, VT

2006 *On The Wall: SAQA @ Colorado Springs*
Gallery of Contemporary Art,
University of Colorado, Colorado Springs, CO

2005 *Art Quilt Network / New York*
Fitton Center for Creative Arts, Hamilton, OH

Beyond Tradition: Contemporary Art Quilts
Carl Solway Gallery, Cincinnati, OH

Rooted in Tradition: The Art Quilt
Foothills Art Center, Golden, CO

World Quilt Carnival, United States
Nagoya Dome, Nagoya, Japan

2004 *SOFA*
del Mano Gallery, Navy Pier, Chicago, IL

A Patchwork Presence
Peoria Art Guild, Peoria. IL

Quilts: Traditional and The Deviant
Art Quilt Network /NY, HUB Robeson Gallery,
Penn State University, State College, PA

2002-03 *Pioneers: Teaching the World to Quilt*
Vermont Quilt Festival, Norwich University, Northfield, VT,
New England Quilt Museum, Lowell, MA, and Primedia
Gallery, Quilter's Newsletter Magazine, Golden, CO

Art Quilts
The Landmark at Eastview, Tarrytown, NY

2002 *The 30 Distinguished Quilt Artists of the World*
Tokyo International Great Quilt Festival: Fabric,
Needles and Thread, Tokyo Dome, Tokyo, Japan

2001 *10th International Triennale of Tapestry*
Central Museum of Textiles, Lodz, Poland. BRONZE MEDAL

Contemporary Art Quilts: The John M. Walsh III Collection
University of Kentucky Art Museum, Lexington, KY

2000 *Quilters' Heritage Celebration 2000*
Lancaster Conference Center, Lancaster, PA

2000 *Art Quilts: America at the Millennium*
Patchwork and Quilt Expo, au Pavillon Josephine, Parc
l'Orangerie, Strasbourg, France

1999-2001 *Evidence of Paradise: One Person Exhibition*
Illinois State Museum Art Galleries, Chicago, Wittington,
Springfield and Lockport, IL

1999 *Last Quarter Century*
Vermont Quilt Festival, 1999 Special Exhibit, Norwich
University, Northfield, VT

1999 *Edge to Edge: Selections From Studio Art Quilts*
Organized by the Museum of American Folk
Art, Heritage Plantation, Sandwich, MA

1998 *Quilts Today: An Artistic Tradition*
Shering-Plough, Madison, NJ

1998 *Art Quilt International*
Chassey en Morvan, Bourgogne, France

1998 *Seeing Through Surfaces*
Marian Gallery, Mt. Mary College, Milwaukee, WI

1998 *Illinois Crossroads: Quilts 1998*
Southern Illinois Art Center, Whittington, and
the Illinois State Museum, Springfield, IL

1998 *Fantastic Fibers*
Yeiser Art Center, Paducah TriArt Gallery, Louisville, KY

1997 *Fabulous to Funky: Contemporary Fiber Art*
Mitchell Museum, Mt. Vernon, IL

1997 *Two-person Exhibition*
Palace of the Hohenems, Hohenems, Vorarlberg, Austria

1996 *Pieces, Parts and Passion*
Lubbock Fine Arts Center, Lubbock, TX

1996 *Glass, Fiber, Wood: The Kindred Eye*
Rockford Art Museum , Rockford, IL

1995 *The Art of the Quilt*
Macculloch Hall Historical Museum, Morristown, NJ

1995 *Common Threads / Uncommon Quilts*
Tempe Arts Center, Tempe, AZ

1995 *Contemporary Quilts from the James Collection*
Museum of The American Quilters Society, Paducah,
KY. Also included in the traveling exhibition.

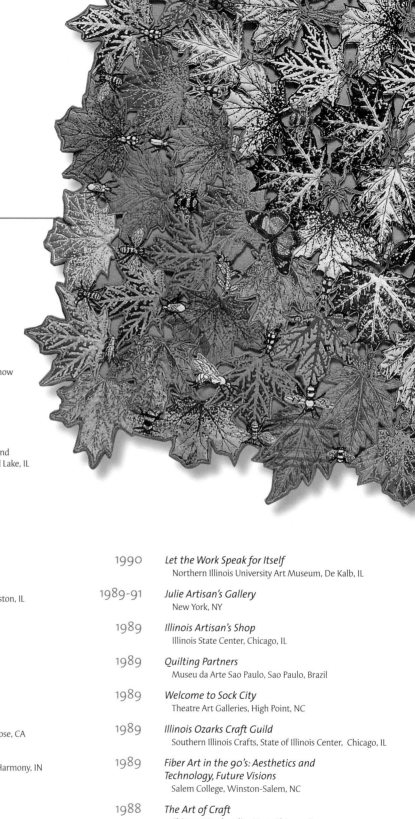

1995-99 *Full Deck Art Quilts*
Also included in the Traveling Exhibition, Renwick
Gallery of the Museum of American Art,
Smithsonian Institution, Washington, DC

1994 *Green on the Red, Red River Revel*
Barnwell Art Center, Shreveport, LA

1994 *The Gathering of the Quilts*
Windfall Dutch Barn, Salt Springville, NY, Best of Show

1993 *Year of the American Craft: A Celebration
of the Creative Works of the Hand*
White House, Washington, DC

1993 *Crafting Currents*
Lockport Gallery, Illinois State Museum, Lockport and
Southern Illinois Arts and Crafts Marketplace, Rend Lake, IL

1993 *Exotic Fiber*
Galesburg Civic Art Center, Galesburg, IL

1992-93 *Gale Willson Gallery*
Southampton, NY

1992 *Metals and Fibers USA Invitational-1992*
Craft Alliance Gallery, St. Louis, MO

1992 *Material Vision: Image and Object*
Tarble Art Center, Eastern Illinois University, Charleston, IL

1992 *Obsessive Compulsive*
Bernice Steinbaum Gallery, New York, NY

1992 *Wearables*
The American Craft Museum, New York, NY

1992 *Julie Artisan's Gallery*
New York, NY

1991 *Green Quilts*
The American Museum of Quilts and Textiles, San Jose, CA

1991 *Current Adornment*
New Harmony Gallery of Contemporary Art, New Harmony, IN

1991 *Let the Work Speak for Itself*
Northern Illinois University Gallery, Chicago, IL

1990-94 *The Definitive Contemporary American Quilt*
Also included in the Traveling Exhibition.
Bernice Steinbaum Gallery, New York, NY

1990 *Let the Work Speak for Itself*
Northern Illinois University Art Museum, De Kalb, IL

1989-91 *Julie Artisan's Gallery*
New York, NY

1989 *Illinois Artisan's Shop*
Illinois State Center, Chicago, IL

1989 *Quilting Partners*
Museu da Arte Sao Paulo, Sao Paulo, Brazil

1989 *Welcome to Sock City*
Theatre Art Galleries, High Point, NC

1989 *Illinois Ozarks Craft Guild*
Southern Illinois Crafts, State of Illinois Center, Chicago, IL

1989 *Fiber Art in the 90's: Aesthetics and
Technology, Future Visions*
Salem College, Winston-Salem, NC

1988 *The Art of Craft*
Chicago Merchandise Mart, Chicago, IL

1988 *Thanatopsis*
Louisville Art Gallery/Watertower Art Association, Louisville, KY

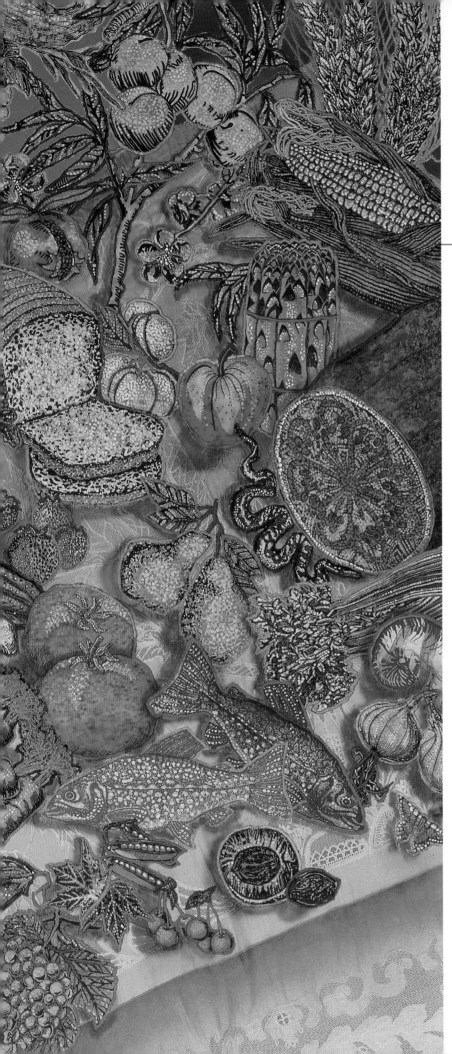

EXHIBITIONS
INVITATIONAL

1987 *Microcosms: Small Scale Textiles*
also included in the traveling show, Lawton Gallery,
University of Wisconsin-Green Bay, Green Bay, WI

1987 *The New Crafts of America*
American Craft at the Armory, American Crafts Council,
Seventh Regiment Armory, New York, NY

1986 *Color, Shape, Texture*
Water Tower Art Association, Louisville, KY

1986 *Art Books*
West Gallery-Art Department, Texas Women's University, Denton, TX

1985 *People East-West Art*
Seikado Gallery, Kyoto, Japan

1985 *Kusaki-zome Exhibition*
Kyoto Prefectural Gallery, Kyoto, Japan

1985 *One Man Show*
Maronie Gallery, Kyoto, Japan

1984-85 *Silk Works Silk Works*
also included in the Traveling Exhibition, American
Silk Mills Gallery, New York, NY

1983 *The New American Quilt*
Gayle Willson Gallery, Southhampton, NY

1983 *One Person Show*
Ariel Gallery, Naperville, IL

1983 *Fiber Foursome*
Worcester Craft Center, Worcester, MA

1983 *One Person Show*
The Craft Alliance, Shreveport, LA

1983 *Needle and Cloth 1973-1983*
The Museums at Hartwick, Hartwick College, Oneonta, NY

1982 *Crafts Now*
Paducah Art Guild, Paducah, KY

1982 *All Books: None Paper*
The Center for Book Arts, Manhattan
Laboratory Museum, New York, NY

1982 *Contemporary Quilts*
Maple Hill Crafts Gallery, Auburn, ME

1982 *Fibers Invitational*
Belk Gallery, Western Carolina University, Culhowee, NC

1982 *Clay-Fiber Invitational*
Peoria Art Guild, Peoria, IL

1981	Boxes: Contemporary Art The Artisan Shop And Gallery, Wilmette, IL	1978	Mad River Regional II Creative Arts Center, Wright State University, Dayton, OH
1981	Photographic Alternatives Liberty Gallery, Louisville, KY	1978	The New Fabric Surface: Printed, Painted and Dyed The Renwick Gallery of the National Collection of, Fine Arts, Smithsonian Institution, Washington DC
1981	Images on Cloth, Film and the City Minneapolis, MN	1978	Fiber Forms '78 Cincinnati Museum of Art, Cincinnati, OH
1981	Material Things Gayle Willson Gallery, Southhampton, NY	1978-80	The Great American Foot The Museum of Contemporary Crafts, New York, NY
1981	The Animal Image: Contemporary Objects and the Beast Renwick Gallery of the National Museum of American Art, Smithsonian Institution, Washington, DC	1978	Surface Design '78 Lafayette Art Center, Purdue University, West Lafayette, IN
1981	One Person Show Art Department, Jones Learning Center, The School of the Ozarks, Point Lookout, MO	1978	Second Annual Exhibit of the Museum of Northern Arizona Art Institute Museum of Northern Arizona, Flagstaff, AZ
1981	Four Person Show Park Central Gallery, Springfield, MO	1978	Clay, Fiber, Metal: Women Artists National Invitational Exhibition Sponsor: The Women's Caucus for Art, Bronx Museum, New York, NY
1980	Greenwood Gallery, Opening Exhibition Washington, DC	1977-78	Artists '77 also included in the Traveling Exhibition Museum of Northern Arizona Art Institute, Flagstaff, AZ
1980	Soft Sculpture Greenwood Gallery, Washington, DC	1977	The Object as Poet Museum of Contemporary Crafts, New York, NY
1979	Collectable Crafts The Signature Shop, Atlanta, GA	1977	Body Covering The Artisan Shop and Gallery, Wilmette, IL
1979	One Person Show Rowe Gallery, University of North Carolina, Charlotte, NC	1977	Group Show New Harmony Gallery of Contemporary Art, New Harmony, IN
1979	Women Artists Springfield Art Association, Springfield, IL	1977	Time in Crafts The Artisan Shop and Gallery, Wilmette, IL
1979	Faces-The Unpainted Portrait John Michael Kohler Art Center, Sheboygan, WI	1977	Into White III The Hand and The Spirit Gallery, Scottsdale, AZ
1978	Fiber Maquettes: A National Invitational Barnhart Gallery, University of Kentucky, Lexington, KY	1977	A Celebration of the Birthday Cake John Michael Kholer Arts Center, Sheboygan, WI
1978	Seven Illinois Quiltmakers Artemisia Gallery, Chicago, IL	1977	Cedarhurst Craft Fair Mitchell Museum, Mt. Vernon, IL
1978	Surface Design: Approaches '78 Liberty Gallery, Louisville, KY	1977	New Directions in Fabric Design Towson State University, Baltimore, MD
1978	Adult Toys 1978 Mindscape Gallery, Evanston, IL	1976	Third Invitational Fibers and Fabrics Exhibition Springfield Art Association, Springfield, IL
1978	Women Selves in Art Gallery I, Mundelein College, Chicago, IL		

EXHIBITIONS
INVITATIONAL

1976 *Textile Constructions-One Man Show*
University of Arizona Student Union, Tuscon, AZ touring exhibition program of the Arizona Commission on the Arts and Humanities and the National Endowment for the Arts

1976 *American Crafts '76-An Aesthetic View*
The Museum of Contemporary Art, Chicago, IL

1976 *Frontiers in Contemporary Weaving*
Lowe Art Museum, University of Miami, Coral Gables, FL

1976 *Gallery Artists Plus*
Kaplan Bauman Gallery, Los Angeles, CA

1976 *Illinois Ozark Invitational*
Gallery Downstairs, Greenville, IL

1976-78 *The New American Quilt*
Also included in the Traveling Exhibition, The Museum of Contemporary Crafts, New York, NY

1976 *Group Show*
Kaplan Bauman Gallery, Los Angeles, CA

1976 *Fiber Invitational*
Gallery 101, University of Wisconsin, River Falls, WI

1976 *Celebration 20 Banner*
Museum of Contemporary Crafts, New York, NY

1976 *Fibers and Fabrics*
Quincy Art Center Gallery, Quincy, IL

1976-78 *New Blues Cyanotype Exhibition*
Also included in the Traveling Exhibition, Memorial Union Art Gallery, Arizona State University, Tempe, AZ

1976 *The Box*
John Michael Kohler Arts Center, Sheboygan, WI

1976 *The Contemporary American Craftsman*
Cheney Cowles Memorial Museum, Spokane, WA

1976 *The Object as Poet*
The Renwick Gallery of the National Collection, of Fine Arts, Smithsonian Institution, Washington, DC

1976 *Body Terrain*
Mano Gallery, Chicago, IL

1975 *Fiber Invitational Showing*
Golden West College, Huntington Beach, CA

1975 *One Person Show*
Memorial Union Art Gallery, Arizona State University, Tempe, AZ

1975 *Pots, Fibers, Drawings: Tom Kendall, M. Joan Lintault, George Asdell*
Prairie House, Springfield, IL

1975 *The Distaff Side / Women Artists*
Mitchell Art Museum, Mt. Vernon, IL

1975 *Coffins to Cradles, The Egg and The Eye*
Los Angeles, CA

1975 *Sewn, Stitched and Stuffed*
Museum of Contemporary Crafts, New York, NY

1973 *Stuffed Art*
Sharadin Gallery, Kutztown State College, Kutztown, PA

1973 *Creative Crafts Exhibition*
Barnwell Art Center, Shreveport, LA

1973 *Fiber Works Exhibition*
Lang Memorial Art Gallery, Scripps College, Claremont, CA

1972 *American Quilts Traditional to Contemporary, The Third Spring*
Washington, DC

1972 *Riverside Fiber Invitational*
Riverside Art Center and Museum, Riverside, CA

1972 *Quilts and Dolls, The Egg and The Eye*
Los Angeles, CA

1967 *Acquisitions, Museum of Contemporary Crafts Memorial Exhibition for David D. Campbell*
New York, NY

1966 *Two Person Show*
Gima's Art Gallery, Ala Moana Center, Honolulu, HI

1962 *Fine Arts Festival Exhibition*
Iowa State University, Ames, IA

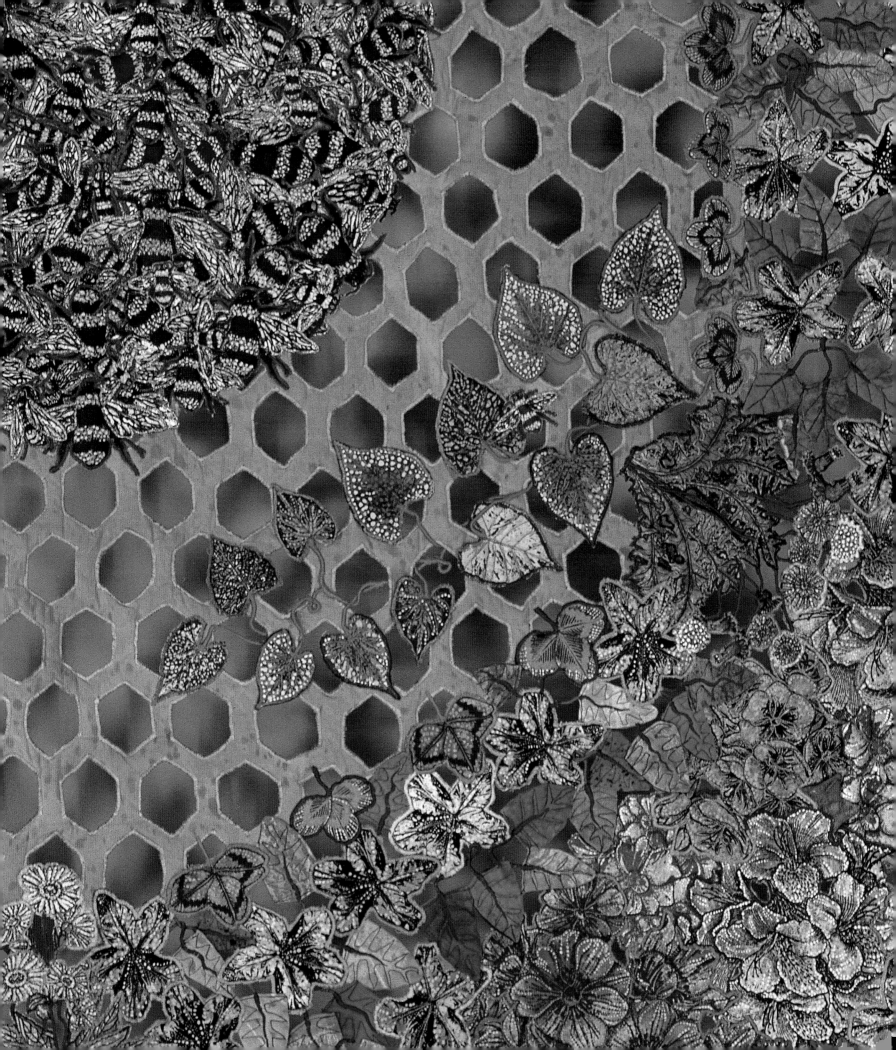

EXHIBITIONS

JURIED AND COMPETITIVE

2003-05 *Masterpieces: Spirit and Strength*
Also included in the Traveling Exhibition, sponsored by Husqvarna
Viking, International Quilt Festivals, US, Europe and Australia

1998 *Visions: Quilt Expressions*
The Museum of San Diego History, San Diego, CA

1996 *8th Internationale Exposition de Patchwork*
Chassey en Morvan, Bourgogne, France, Awards: Le Chassy d'Or and
Prix du Publix

1996 *Visions: Quiltart*
The Museum of San Diego History, San Diego, CA

1996 *American Quilters Society Annual Exhibition*
Paducah, KY

1994 *11th Annual Hands Grand Prix Exhibition*
Bunkamura (The Museum) Tokyo and IMP Hall, Osaka, Japan.
Honorable Mention

1993 *Quilt National 93*
The Dairy Barn, Southeastern Ohio Cultural Arts Center, Athens, OH

1992 *The Quilt Show*
Holtzman Art Gallery, Towson State University, Baltimore, MD

1991 *Visions: The Art of The Quilt*
Museum of San Diego History, San Diego, CA

1989 *Fall Fashion Show*
The Textile Arts Center, Chicago, IL

1989 *Fiber Celebration*
Art Link, Fort Wayne, IN

1989 *Materials: Hard and Soft*
Greater Denton Arts Council, Center for the Visual Arts, Denton, TX

1989 *Crafts 23*
Central Pennsylvania Festival of the Arts, State College, PA

1989 *Fish: An Exhibit*
Also included in the Traveling Exhibition,
Hockaday Center for the Arts, Kalispell, MT

1989-90 *Fiber Art Exhibit*
Packwood House Museum, Lewisburg Council on the Arts,
Lewisburg, PA. Second Prize

1989 *FiberAlaska '89*
The Anchorage Weavers and Spinners Guild, Anchorage, AL

1989 *Paper Fiber XII*
Iowa City/Johnston County Arts Council, Iowa City, IA

1989 *Breaking New Ground,*
 An Exhibition of Contemporary Quilts
 New England Quilt Museum, Lowell, MA

1989 *Expressions in Quilting '89*
 Barrington Area Arts Council, Barrington, IL

1988 *Designed to Wear*
 Oregon School of Arts and Crafts, Portland, OR

1988 *Wearable Art Festival*
 Kaleidoscope Gallery, Barrington, IL

1988 *Fiber Arts Competition*
 Also included in the Traveling Exhibition Creative Arts Guild, Dalton,
 GA. First Prize

1988 *Paper/Fiber XI*
 Iowa City/Johnson County Arts Council, Iowa City, IA

1987 *Fiber National '87*
 Adams Memorial Gallery, Dunkirk, NY

1987 *Small Scale*
 Textile Arts Centre, Chicago, IL

1987 *National Quilting Association, 1987 Annual Show*
 Kirby Field House, Lafayette College, Easton, PA

1987 *Mid-States Craft Exhibition*
 Evansville Museum of Arts and Science, Evansville, IN

1986 *The Wichita National*
 The Wichita Art Association, Wichita, KS

1986 *Containers '86*
 Hickory Street Gallery, St. Louis, MO

1986 *Currents '86, Contemporary Work East of the Mississippi*
 Middle Tennessee State University, Murfreesboro, TN

1986 *Art Books*
 West Gallery, Texas Women's University, Denton, TX

1985 *Clay and Fiber Show*
 The Octagon Art Center, Ames, IA

1984 *Paper / Fiber VII*
 Iowa City/Johnson County Arts Council, Clapp Recital Hall,
 Iowa City, IA

1984 *Mid-States Crafts Exhibition*
 Evansville Museum Of Arts and Sciences Evansville, IN. Merit Award

1983 *Breaking the Bindings, American Book Art Now*
 Elvehjern Museum of Art, Madison, WI

1983 *A Patch in Time, Calgary Quilt Conference*
 Banff Centre, Eric Harvie Theatre, Banff, Alberta, Canada

1982 *Copy Cat Show*
 Franklin Furnace, New York, NY

1982 *Invitational Fibre II*
 Skyloom Fibers, Boettcher Concert Hall, Denver, CO

1981 *Ceremonial and Liturgical Objects,*
 Craft Alliance Gallery, St. Louis, MO

1981 *Quilt National '81*
 Southeastern Ohio Cultural Center, The Dairy Barn, Athens, OH

1981 *Crafts 1981 Now*
 Coos Art Museum, Coos Bay, OR. Honorable Mention

1981 *Women in Design International, Competition 1981*
 San Francisco, CA. Certificate of Honor

1980 *It's About Time*
 The Worcester Craft Center, Worcester, MA

1979 *From Camera to Cloth*
 Rend Lake College, Ina, IL

1979 *Mid-West Surface Design*
 The Gallery, Kent State University, Kent, OH

1979 *Mississippi River Craft Show*
 Brooks Memorial Art Gallery, Memphis TN

1979 *Objects '79*
 Western Colorado Center for the Arts, Grand Junction, CO.
 Judge's Choice Award

1979 *Beaux Arts Designer / Craftsmen '79*
 Columbus Museum of Art, Columbus, OH. Fiber Award

1979 *Crafts '79 Now*
 Coos Art Museum, Coos Bay, OR

1979 *Beds, Sweet Dreams and Other Things*
 Brunnier Gallery, Iowa State Center, Iowa State University, Ames, IA.
 Award Of Excellence

1979 *Juried Show, Fiber, Wood, Stone, Plastic*
 Summit Art Center, Summit, NJ. Honorable Mention

1979 *Illinois Crafts '79*
 Ilinois State Museum, Springfield, IL. Merit Award

1979 *Stitchery '79*
 Arts and Crafts Center, Pittsburgh, PA. Juror's Award

EXHIBITIONS

JURIED AND COMPETITIVE

1978 *International Self-Portrait Invitational*
North Light Gallery, Arizona State University, Tempe, AZ

1978-80-82 *Third International Exhibition of Miniature Textiles*
European and American Tour

1978 *Survey of Illinois Fiber*
Lakeview Museum Of Arts and Sciences, Peoria, IL

1978 *The Great American Needlework Show*
The Montalvo Center for the Arts, Saratoga, CA

1978 *Needlework / 78*
Des Moines Symphony Guild, Employers Mutual Building,
Des Moines, IA. Award

1978 *National Mini-Tapestry Exhibit*
The Gathering, Kansas City, MO

1978 *Needle Expressions*
First Biennial Juried Exhibit of Needlework, Tulsa, OK

1978 *Juried Show 2, Paper/Clay/Metal/Glass/Fiber*
Summit Art Center, Summit, NJ

1978 *Clay and Fiber*
The Octagon Art Center, Ames, IA

1977 *Mid-West Craft Exhibition*
The Rochester Art Center, Rochester, MN

1977 *Toys Designed by Artists*
Arkansas Art Center, Little Rock, AR

1977 *Hip-Pocket Weaving*
Center for the Visual Arts, Illinois State University, Normal, IL

1977 *The Monumental Midwestern Award Exhibition*
The Water Street Art Center, Milwaukee, WI

1977 *Clay, Fiber, Glass*
Neville Public Museum, Green Bay, WI

1977 *Beaux Arts Designer/Craftsman '77*
Columbus Gallery Of Fine Arts, Columbus, OH

1977-78 *Stitchery '77*
Also included in the Traveling Exhibition, Arts And Crafts Center,
Pittsburgh, PA. Judge's Choice Award

1977 *Xerox, Xerox, Xerox*
Gallery 110, Department of Fine Arts, University Of Colorado,
Boulder, CO

1977 *Mid-States Craft Exhibition*
Evansville Museum of Arts and Sciences, Evansville, IN

1977 *Juried Show I*
Summit Art Center, Summit, NJ
Award Of Excellence

1977 *Illinois Crafts 1977*
Illinois State Museum, Springfield, IL. Merit Award

1976 *Designer Craftsmen '76*
Richmond Art Center, Richmond, CA

1976 *Eight State Annual Crafts Exhibition*
J.B. Speed Art Museum, Louisville, KY

1976 *Mid-States Crafts Exhibition*
Evansville Museum Of Arts and Sciences, Evansville, IN

1976 *Fabric and Fibers, 1976*
Quincy Art Club, Elizabeth M. Sinnock Gallery, Quincy, IL

1976 *Toys Designed By Artists*
The Arkansas Arts Center, Little Rock, AK
Purchase Prize

1975 *Miniature Works, Crafts and Sculpture Exhibition*
The Museum of Texas Tech University, Lubbock, TX

1975 *18th Annual National Art Round-up*
Las Vegas Art Museum, Lorenzi Park, Las Vegas, NV

1975 *The Mississippi River Craft Show*
Brooks Memorial Art Gallery, Memphis, TN

1975 *Mid-States Craft Exhibition*
Evansville Museum Of Arts and Sciences, Evansville, IN
Honorable Mention

1975 *Illinois Craftsmen*
Illinois State Museum, Springfield, IL

1973-75 *Technology and the Artist-Craftsmen*
The Octagon Art Center, Ames, IA
Also included in the traveling exhibit. Honorable Mention

1974 *The Sixty Third Annual Exhibition*
The Texas Fine Arts Association, Austin, TX

1973 *Mid-States Crafts Rexhibition*
Evansville Museum of Arts And Sciences, Evansville, IN

1973 *Southern California Designer Craftsmen*
Riverside Art Center, Riverside, CA

1973 *Southern California Designer Craftsmen*
Laguna Beach Museum Of Art, Laguna Beach, CA
Also included in the traveling exhibition

1973 *Quilts and Coverlets*
 Bloomfield Art Association, Birmingham, MI

1972 *Southern Tier Arts and Crafts Show*
 The Corning Museum Of Glass, Corning Glass Center, Corning, NY

1972 *10th Annual Purchase Prize Competition*
 Riverside Art Center, Riverside, CA

1971 *Design XI*
 Pasadena Art Museum, Pasadena, CA

1971 *Object Makers*
 Utah Museum of Fine Art, University of Utah, Salt Lake City, UT

1969-70 *Young Americans*
 Also included in the traveling exhibition,
 The Museum of Contemporary Crafts, New York, NY

1969 *Media Crafts Show-Quilts and Blunt Instruments*
 Civic Art Gallery, Walnut Creek, CA

1969 *California Crafts VI, Pacific Dimensions*
 Crocker Art Gallery, Sacramento, CA

1969 *Hawaii Craftsmen's Annual*
 Ala Moana Center, Honolulu, HI
 ASID Award

1966 *Artists Of Hawaii, 1966, 17th Annual Exhibition*
 Honolulu Academy of Arts, Honolulu, HI

1962 *Mid-West Designer Craftsmen Exhibition*
 Kalamazoo Institute of Art, Kalamazoo, MI

1962 *Mid-States Crafts Exhibition*
 Evansville Museum of Arts And Sciences, Evansville, IN

1961 *Mid-States Art Exhibition*
 Evansville Museum of Arts and Sciences, Evansville, IN

1961 *Mississippi River Craft Show*
 Brooks Memorial Art Gallery, Memphis, TN

1961 *Mid-States Crafts Exhibition*
 Evansville Museum of Arts And Sciences, Evansville, IN

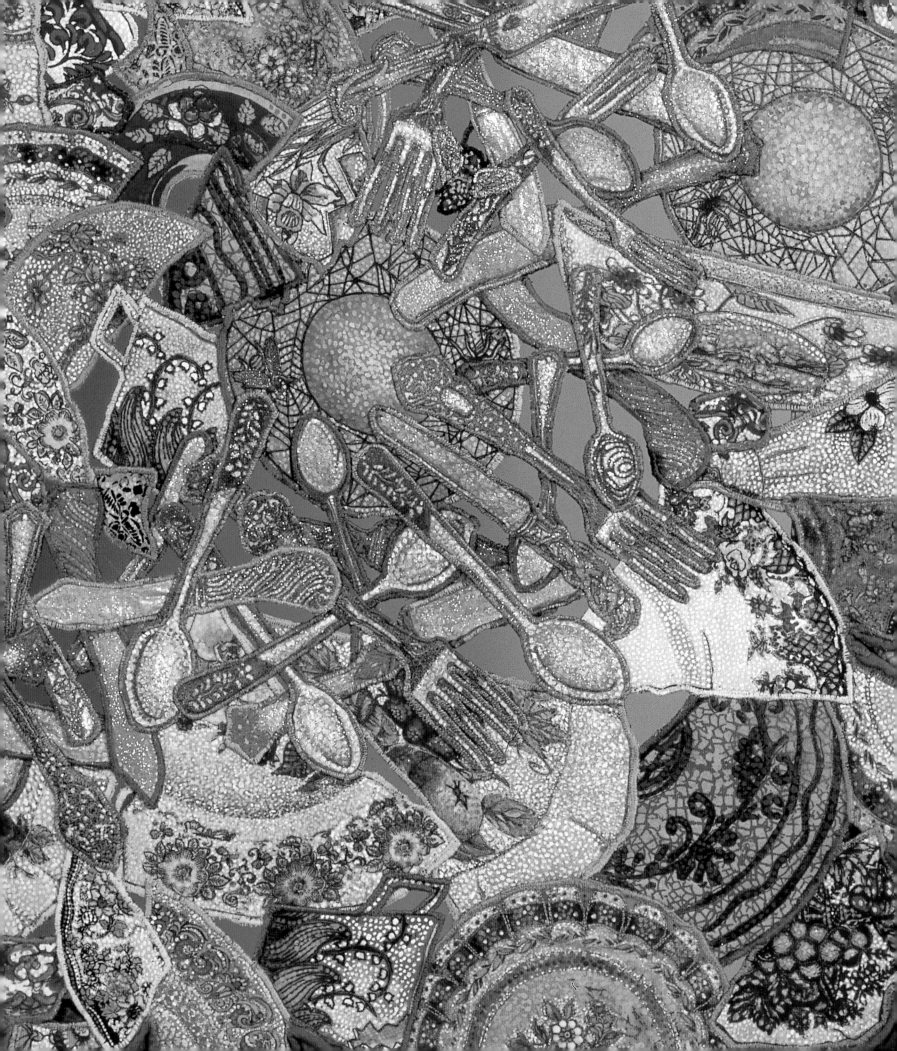

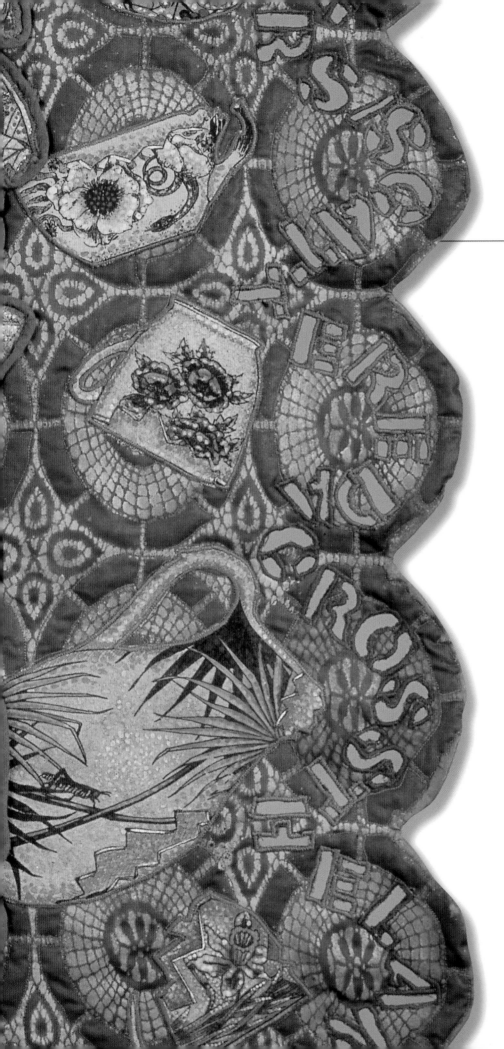

COLLECTIONS

Northern Illinois University
De Kalb, IL

Illinois State Museum
Springfield, IL

Quilt Collection of John Walsh III

GrowMark Inc
Bloomington, IL

Ardis and Robert James Quilt Collection
International Quilt Study Center
University of Nebraska, Lincoln, NE

Collection of International Quilt Study Center
University of Nebraska, Lincoln, NE

Pere Marquette State Park
Grafton, IL

Charter Bank
Carbondale, IL

Evansville Courier
Evansville, IN

Arkansas Art Center
Little Rock, AR

American Craft Museum
New York, NY

Lakeview Museum of Arts and Sciences
Peoria, IL

Danville Junior College
Danville, IL

Dun-Richmond Economic Center
State of Illinois, Carbondale, IL

Full Deck Quilt Collection of
Warren and Nancy Brakensiek
Los Angeles, CA

Hoffman Estates Public Library
Schaumburg, IL

Rocky Mountain Quilt Museum
Golden, CO

John Walsh III Quilt Collection
Sommerville, NJ

and numerous private collections

PUBLICATIONS

ARTICLES IN PROFESSIONAL JOURNALS

Lintault, M. Joan, *Kusaki-zome: Traditional Japanese Grass and Tree Dyes*, pp. 16-19 and *Kalamkari: Dye Painted Fabrics of Sri Kalahasti*, pp. 86 -88, *Dyes From Nature, Brooklyn Botanic Garden Record, Plants and Gardens,* Summer Issue 1991, Vol.46 #2, Handbook #124.

Lintault, M. Joan, *Fabric Painting in India: "The Kalamkaris of J. Gurappa Chetty, On the Surface." Fiberarts*, January/February 1982, Vol. 9, No 1, pp. 64-66.

Lintault, M. Joan, *Kusaki-zome, (Traditional Japanese Grass and Tree Dyes), Turkey Red Journal*, Volume 1, Issue 1, August 1996 Issue 2. pp. 4-5, Volume 2, Issue 1, April 1996. pp. 5-6, Volume 3, Issue 3, February 1997 pp.2-3.

CHAPTERS IN PROFESSIONAL BOOKS

Lintault, M. Joan (Quilting and Patchwork Editor) *The Whole Earth Epilog*, Penguin Books, Baltimore, 1974, pp. 572-573.

WORK PUBLISHED IN BOOKS

Shaw, Robert, essay, Sandinsky, Rachael, *Contemporary Art Quilts: The John M. Walsh III Collection*, University of Kentucky Art Museum, Lexington, Kentucky 2001, pp. 12, 28, 29, 30.

Orban, Nancy, Editor, *Fiberarts Design Book Six*, Asheville, NC: Lark Books, 1999, p. 132.

Austin, Mary Leman, Editor, *The Twentieth Century's Best American Quilts*, Primedia Special Interest Publications, 1999, p.48.

George, Phyllis, *Living With Quilts*, GT Publishing Co. 1998, pp. 140-143.

Shaw, Robert, *The Art Quilt*, Hugh, Lauter, Levin Associates, 1997, pp 26, 28, 47, 50-51, 62, 82, 114-115, 124, 260, 292-293.

Laury, Jean Ray, *Images on Fabric*, C and T Publishing, CA, 1997, pp. 50, 96.

Rodgers, Janet, (Editor), *Visions: Quiltart*, C & T Publishing Company, Lafayette, CA, 1996, p. 84.

Mc Morris, Penny and Kile, Michael, *The Art Quilt*, Quilt Digest Press, 1996, Plate Number 27.

Shaw, Robert, *Quilts: A Living Tradition*, Hugh Lauter Levin Associates, 1995, pp. 248, 250, 276, 278, 279.

Batchelder, Ann and Orban, Nancy, (Editors), Lark Books, Asheville, NC: *Fiberarts Design Book Five*, 1995, p. 31.

McMorris, Penny and Cullinan, Helen, *Contemporary Quilts from The James Collection*, American Quilters Society, Paducah, KY, p. 38.

Pierce, Sue and Suit, Verna, *Art Quilts: Playing With a Full Deck*, San Francisco: Pomegranate Artbooks, 1994, pp. 15, 23, 35, 39, 107.

Ramsey, Bets, *Art and Quilts: 1950-1970, Uncoverings 1993*, Volume 14 of the Research Papers of the American Quilt Study Group, 1994, American Quilt Study Group. pp. 9, 25, 26-30.

Timby, Deborah Bird, (Editor) *Visions the Art of the Quilt*, Quilt San Diego, C and T Publishing, 1992, p. 31.

Wada, Naoko, Interview, *Utsukushi Kimono*, Winter 1983, No 126, Tokyo, Japan: Fujin Gako Publishers, pp. 335-336.

Hall, Carolyn Vosburg. *Soft Sculpture*, Davis Publications, 1981, p. 94.

Hall, Carolyn. *The Sewing Machine Craft Book*, Van Nostrand and Reinholdt 1980, p. 97.

Howell-Koehler, Nancy. *Photo Art Processes*, Worcester, MA: Davis Publications, 1980, p. 95.

Scott, Toni. *The Complete Book of Stuffed Work*, Boston: Houghton Mifflin Co., 1978, pp. 29, 97.

Brown, Elsa. *Creative Quilting*, New York: Watson Guptill Publishers, 1975, pp. 46, 85.

Newman, Thelma R. *Quilting, Patchwork, Applique and Trapunto*, New York: Crown Publishers, 1974.

Hall, Carolyn Vosburg. *Stitched and Stuffed Art*, New York: Doubleday and Co. 1974, pp. 148-150.

Meilach, Dona Z. *Soft Sculpture*, New York: Crown Publishers, 1974, pp. 42, 90.

Laury, Jean Ray. *Quilts and Coverlets: A Contemporary Approach*, New York: Van Nostrand and Reinholdt, 1970, pp. 64, 74-75.

Moody, Ella (ed.) *Decorative Art In Modern Interiors: Year Book of International Decoration* Vol. 60, London: Studio Vista Ltd., 1970, p.109.

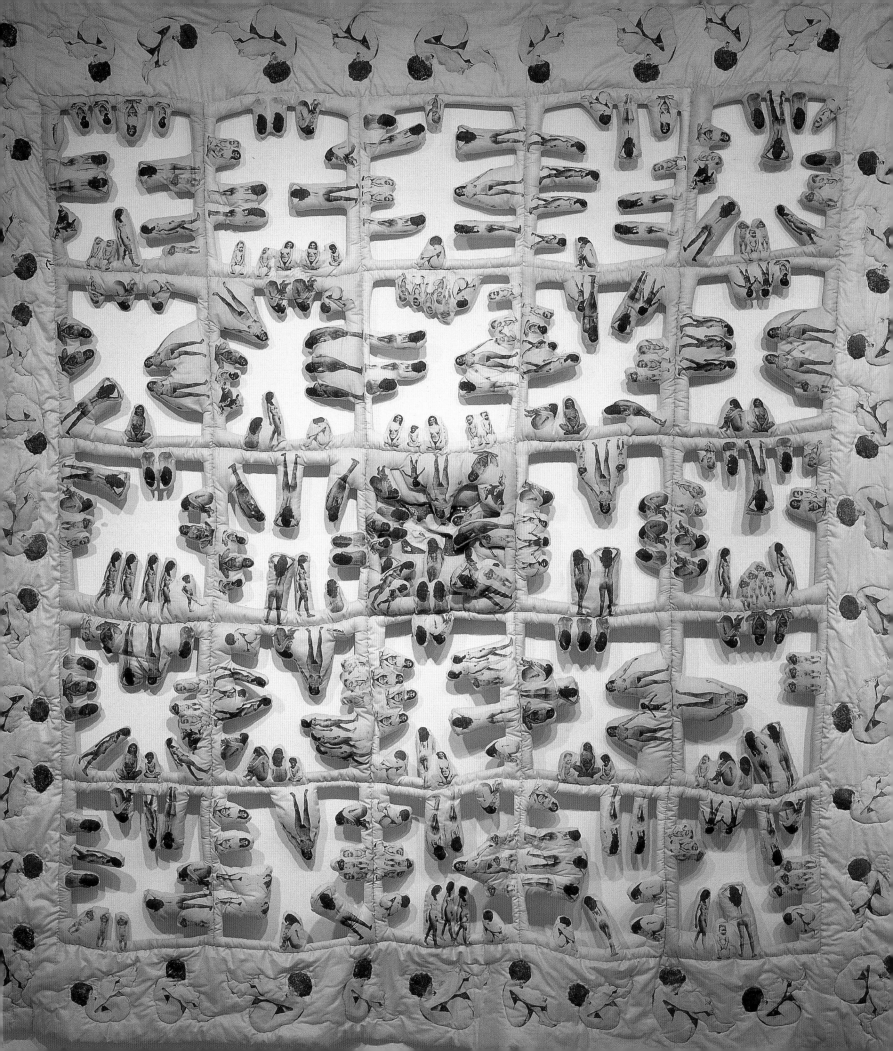

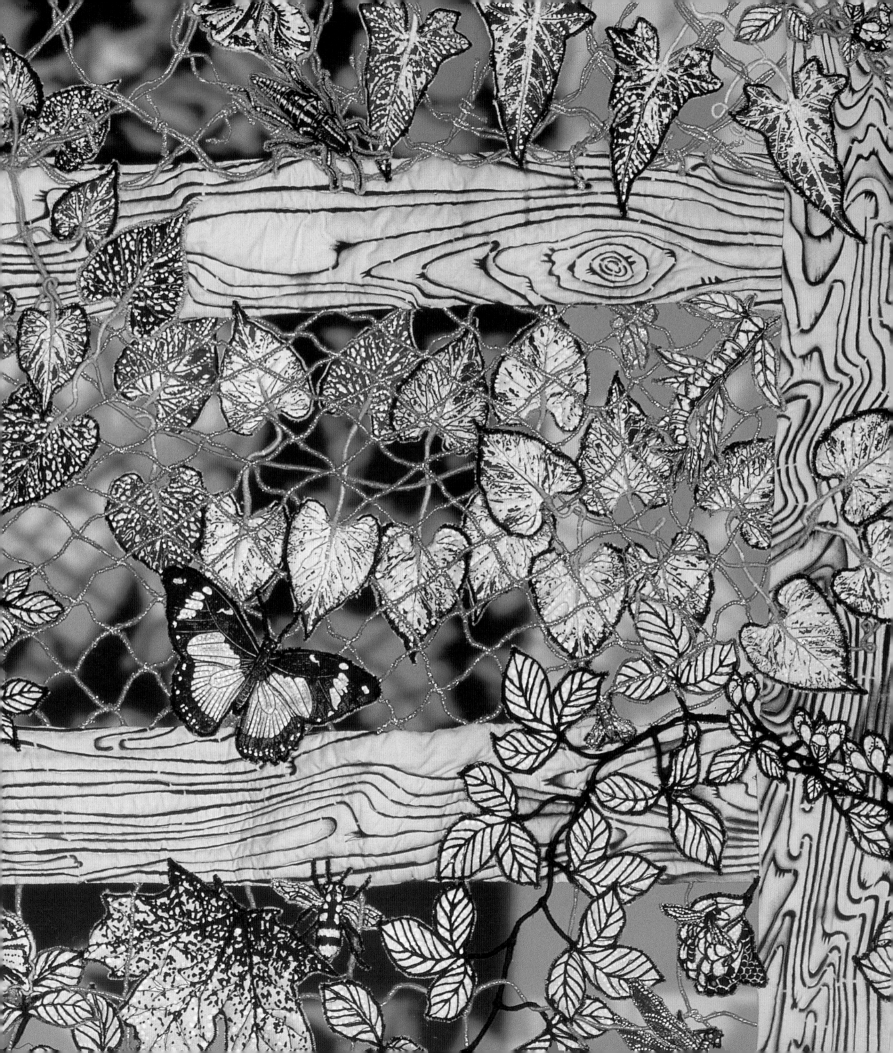